BARNSTAPLE

THROUGH TIME

Denise Holton &
Elizabeth Hammett

AMBERLEY PUBLISHING

First published 2013

Amberley Publishing
The Hill, Stroud, Gloucestershire, GL5 4EP
www.amberley-books.com

Copyright © Denise Holton & Elizabeth Hammett, 2013

The right of Denise Holton & Elizabeth Hammett to be
identified as the Authors of this work has been asserted
in accordance with the Copyrights, Designs and Patents
Act 1988.

ISBN 978 1 4456 0851 8

British Library Cataloguing in Publication Data.
A catalogue record for this book is available from the
British Library.

Typesetting by Amberley Publishing.
Printed in Great Britain.

Introduction

By 930, the date that Barnstaple traditionally claimed to have received its first charter, the basic layout of the town was already in place. Boutport Street and the High Street were in existence with a strong defensive wall surrounding the town.

Barnstaple was one of four 'Burhs' and as such was allowed to mint coins. The earliest known coin made here dates back to King Eadwig's reign (955–59). The town was also important as a centre of commerce. Its old name, 'Bearde Staple', means the Market or Staple of Bearda. According to tradition, King Athelstan granted the town a charter with rights to hold markets and a fair.

By 1066 Barnstaple was a well-established town, and twenty years later was mentioned in the Domesday Book where it states:

> The King has a Borough called Barnstaple which King Edward held T.R.E. There the King has 40 burgesses within the borough and nine without and they pay 40 shillings by weight to the King and 20 shillings by tale to the Bishop of Coutances. There also 23 houses have been laid in ruins since King William has had England.

The King held the borough of Barnstaple for himself, and it was not until Henry I came to the throne that the first Lord of Barnstaple, Judhael of Totnes, was created. It was Judhael who in 1107 founded the priory of St Mary Magdalene outside the town wall.

By 1290 Barnstaple had become an important trading centre, in particular for wool and woollen material, and five years later it sent two burgesses to represent the town in Parliament.

The late sixteenth and early seventeenth centuries were the most exciting period in Barnstaple's development. The great quay was built at this time, making it easier for ships to load and unload goods, leading to a great increase in trade. Tobacco was imported from the New World and pottery, tools, cloth and other goods were exported in return. In 1603, work began on the building of a new quay, to cope with the expanding trade.

In 1642 the Civil War began. Barnstaple was first held by the Parliamentarians but changed hands four times before the end of the war. It was in June 1645 that Prince Charles (the future Charles II), on the run from the plague in Bristol, took refuge in the town, before moving on in July.

After the war, Barnstaple settled down to consolidate its position as a port and industrial centre, and in the eighteenth century, Queen Anne's Walk was created in its present form as a merchants' exchange. Marshy land at the end of the bridge was drained, and in 1710 the first proposals were made to create a formal square. Several roads leading to Barnstaple were repaired and widened after George III passed an Act requiring this work to be carried out.

In 1825 steam was used for the first time in Barnstaple to power lace bobbins at the Derby Mill factory, and a year later the present Guildhall was built, replacing the Old Guildhall (actually Barnstaple's second), which stood at the entrance to the churchyard. During the first half of the century, the population had doubled to 8,500, and by 1835 the town's boundaries were extended to include Pilton and Newport. There was much redesigning taking place, and in 1854 the Barnstaple to Exeter railway opened.

The continuing silting of the River Taw resulted in the running down of Barnstaple as a port, and as time passed the major part of the woollen industry moved to other parts of the country, with other, larger ports taking much of Barnstaple's trade.

However, the twentieth century saw a gradual resurgence of Barnstaple's fortunes, with several major firms settling in the town at Pottington and Roundswell, and as we move further into a new century Barnstaple continues to flourish as the chief town of North Devon.

It has been fascinating to put this book together, and matching up the old and new photographs has presented a real challenge. Some have been easy to match, with hardly any changes to note. But others have seen so much change that an exact match has been almost impossible. One surprising thing we have noticed is the increased proliferation in trees. On many occasions the appearance of newly placed trees and greenery has caused huge problems with matching the views, totally challenging our general assumption that there were more trees in the past than there is today.

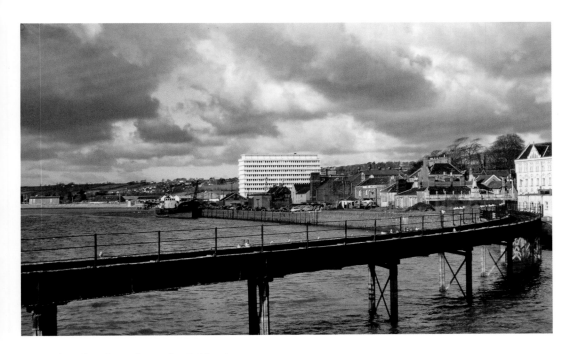

The Riverfront from the Bridge I

This photograph can be dated to between 1967 and 1977. The foundation stone of the civic centre, which dominates the riverfront in both old and new photographs, was laid by Sir Francis Chichester in 1967. The curved railway bridge in the foreground of the old photograph was demolished in 1977. It had crossed the river for over 100 years from 1874 when the railway line was extended to Ilfracombe. That line ceased to run in 1970, making the iron bridge redundant.

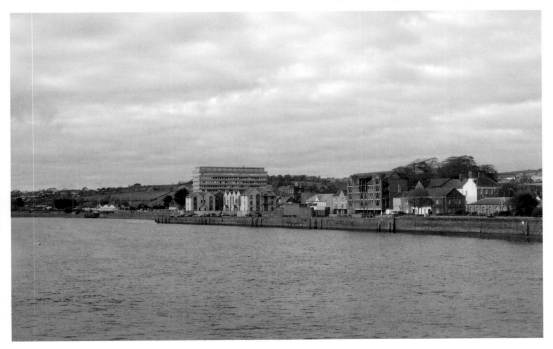

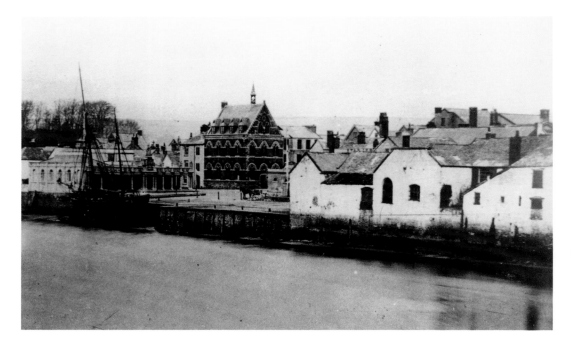

The Riverfront from the Bridge II

These two photographs clearly show the major changes to the riverfront in the last 150 years. The very early photograph is one of the few to show a ship moored near Queen Anne's Walk. This is also one of the few photographs taken before the railway was extended across the river in 1874. After the railway line was extended to Ilfracombe, the quay outside Queen Anne's Walk disappeared and Castle Quay was constructed. Nearly all the other buildings along the river were swept away in the major rebuilding of the 1920s.

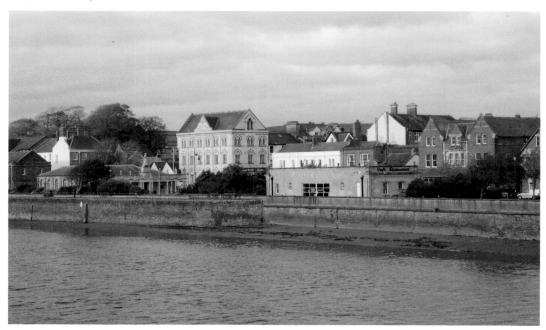

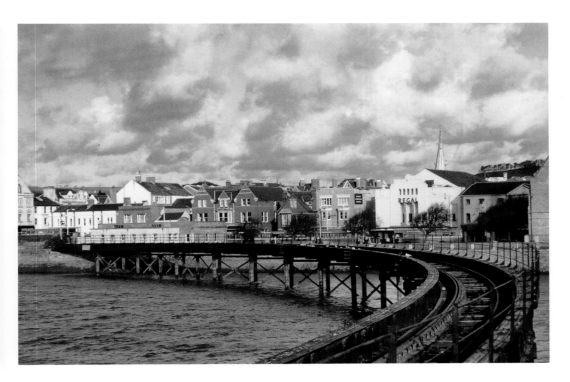

The Riverfront from the Bridge III
Another view of the riverfront, showing more of the curved railway bridge, which was 213 yards long and curved through 90 degrees. The end of Bridge Chambers can be seen on the right and nearby, but in fact on the other side of the road is the Regal cinema, dating from 1937. The building survives, but is no longer a cinema.

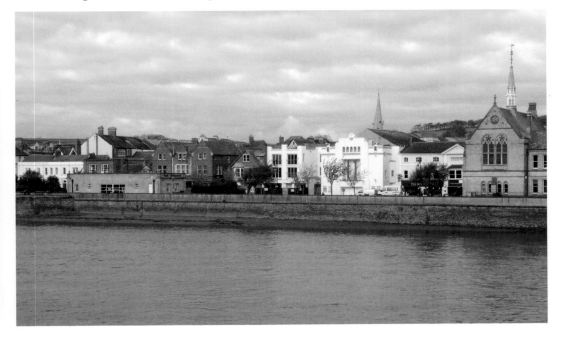

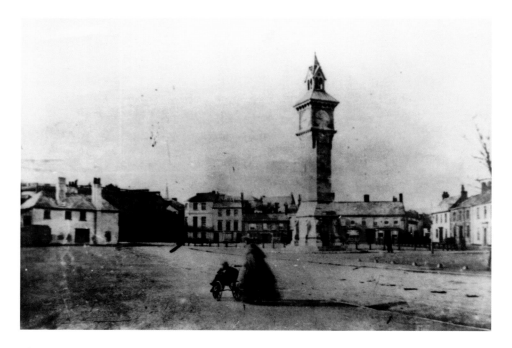

The Square I

This photograph also appears to date from around 1865, when the Albert Clock was new. It was constructed in 1862 as a memorial to Prince Albert, Queen Victoria's husband, who died in 1861. The modern photograph also shows another Victorian building, erected ten years after the clock. It now houses the Museum of Barnstaple & North Devon, but was built as a private house, becoming the North Devon Athenaeum in 1888 when it was purchased by W. F. Rock for that purpose.

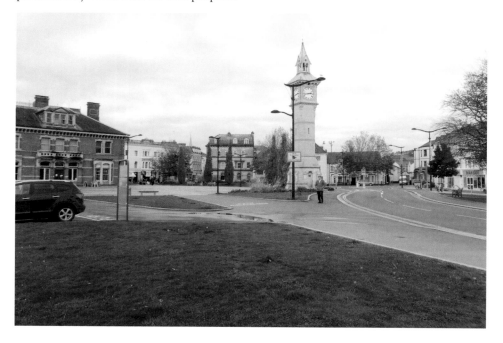

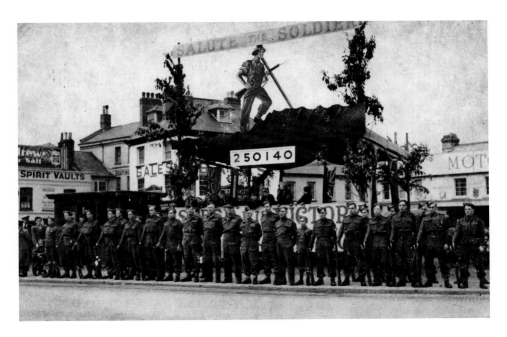

The Square II

This photograph shows a victory parade, presumably at the end of the Second World War. Behind the soldiers, Bale's garage can just be seen on the left and Prideaux's garages on the right. There have been major changes in this area of the Square since then, with the construction of the inner relief road and the new flats on the left. In the modern photograph can be seen the memorial bust of Charles Sweet Willshire, a councillor and magistrate, who was once called 'the most famous man in North Devon' but is now forgotten.

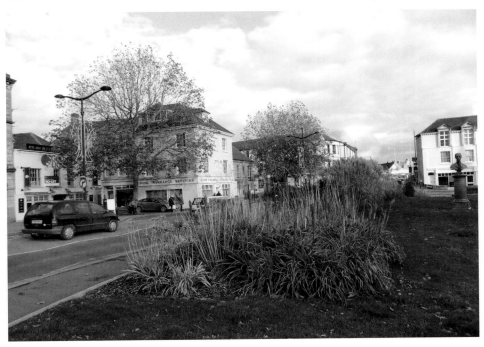

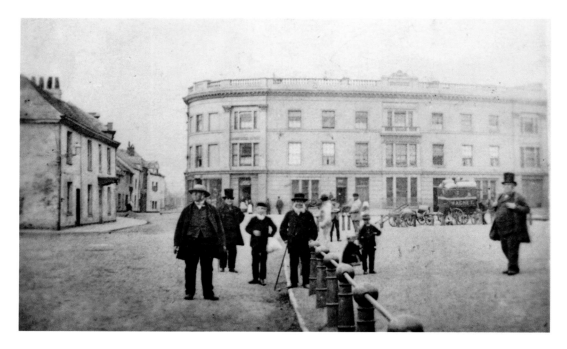

The Square III

This old photograph from 1865 shows the Square before the gardens were laid out later in the Victorian era. Until the eighteenth century this area was a marsh, and causeways were needed to get from the end of the bridge to High Street and from Litchdon Street to the town. The most obvious difference between these photographs is that Bridge Buildings (on the right) appears in both, but Bridge Chambers (on the left) only appears in the modern photograph. They were both built by the Bridge Trust and designed by R. D. Gould, but thirty years apart, with Bridge Buildings dating from 1844 and Bridge Chambers from 1874.

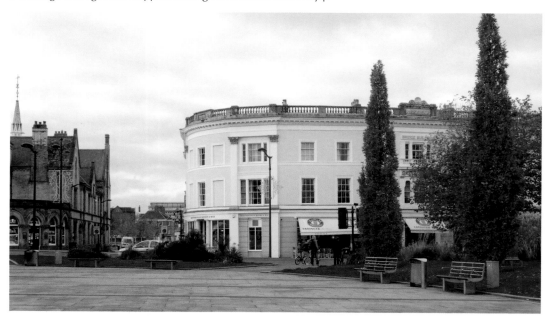

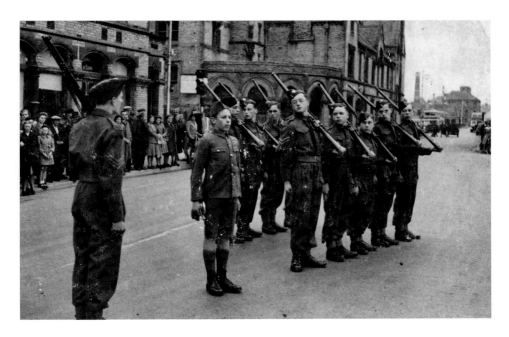

The Square IV

Another photograph from the 1940s. In both old and new photographs Bridge Chambers can be seen on the corner of the bridge and the Strand. In the earlier photograph can be seen the similar building that existed on the other side of the bridge but was demolished in the 1960s when the bridge was widened. Looking down the Strand, the most obvious difference is the civic centre, which appears at the end in the modern photograph.

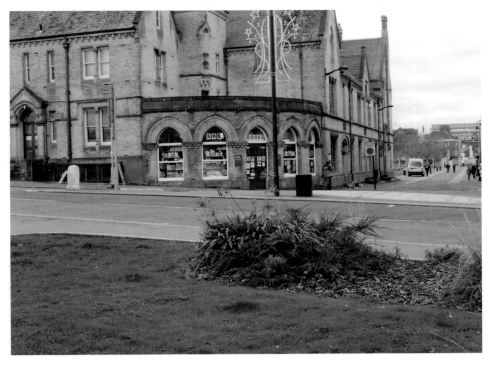

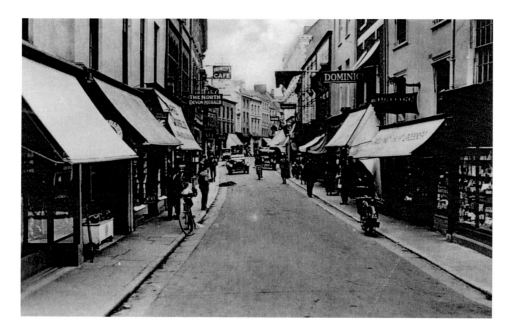

High Street I

High Street has always been the main street in Barnstaple, but in earlier centuries only the middle section was called 'High' Street. Early Barnstaple was a walled town with four gates. This end of the street was the site of the south gate and so was called Southgate Street. The other end was the site of the north gate and was known as Northgate Street. Although the south gate disappeared centuries ago, there is a small section of the stonework contained in Youings', part of which is shown on the lower right of the modern photograph. This is their new shop, built in the modern style in 1934. The firm began trading in Barnstaple in 1884 in Boutport Street.

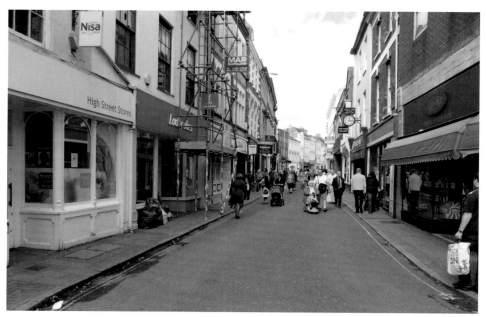

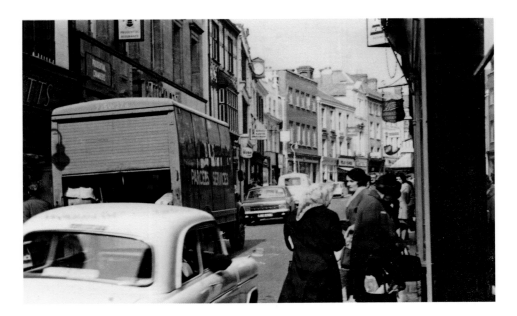

High Street II

The most obvious difference between these photographs is the lack of traffic in the modern picture, but this is only because traffic is now prohibited during the main part of the day. One feature that appears in both old and new photographs is the clock at the top of the building near the middle on the left. A couple of buildings along from the clock is No. 96 High Street, now a restaurant, but which was occupied by the *North Devon Journal* from 1854 and modernised in 1957.

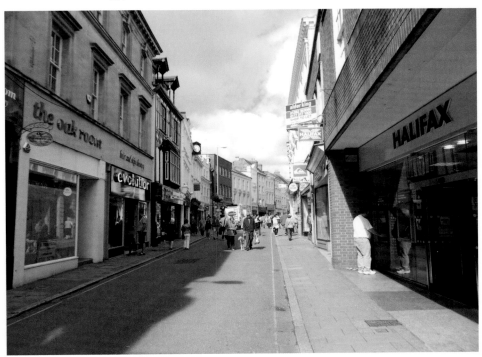

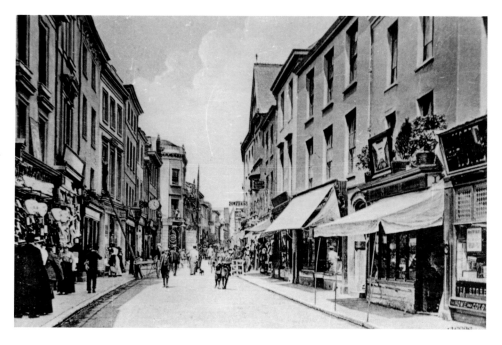

High Street III

Although the old photograph here is clearly much older than the previous photograph, many of the upper stories are still the same, especially on the left. The lower front right has changed, although the sloping roof nearby is the same. The entrance to Cross Street is near the top of the photograph on the left, and the curved building on one side, now housing a building society, can be seen in both photographs.

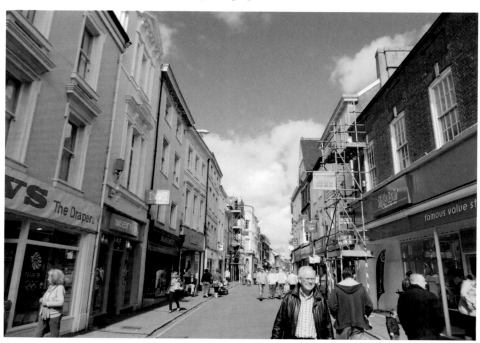

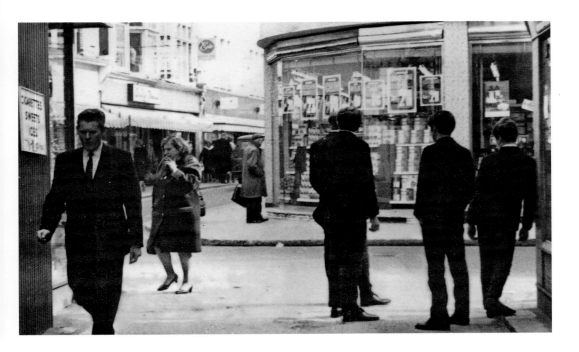

High Street IV

These photographs are taken from High Street, at the entrance to Holland Street, looking across to the corner of Joy Street. From the style of clothing and haircuts, the old photograph is probably from the 1960s. Although the appearance of the shop on the right is much the same, the left-hand corner has been completely altered and now forms part of the Green Lane shopping centre.

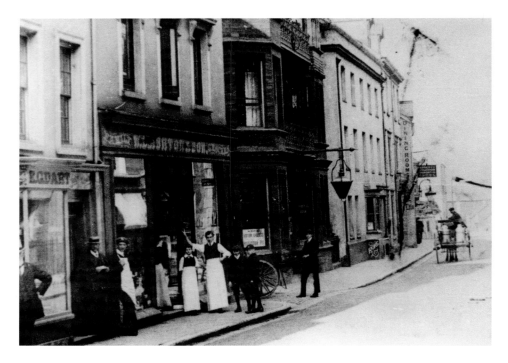

High Street V

These photographs were taken much further down High Street and show the entrance to Gammon Lane on the left. The old photograph, dating from around 1900, shows Ashton's family grocer with the staff posing outside the building, which has now disappeared to be replaced by the building shown in the modern photograph. The building on the other side of Gammon Lane is the same in both photographs. Opened in 1888 as the Victoria Temperance Hotel, it later housed council offices and is now known as Victoria Chambers.

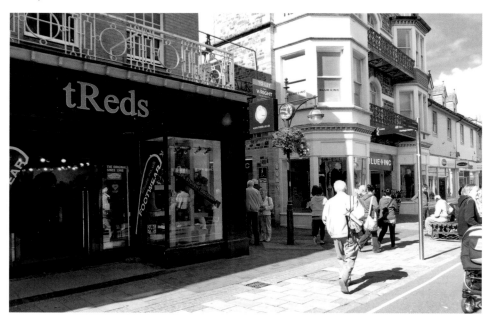

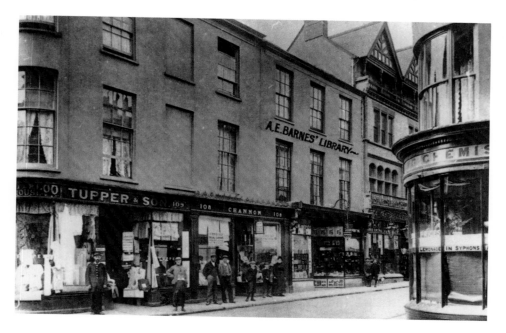

High Street VI

Another view of this end of High Street, with the Youings building and its predecessor just visible on the right. The architecture of the buildings on the left is remarkably similar in both old and new photographs, apart from some alterations to the shopfronts. On the left-hand side is the building with a display window on the corner and the shop entrance behind, which has had many occupiers but was for several years the premises of Briggs & Co. shoe shop.

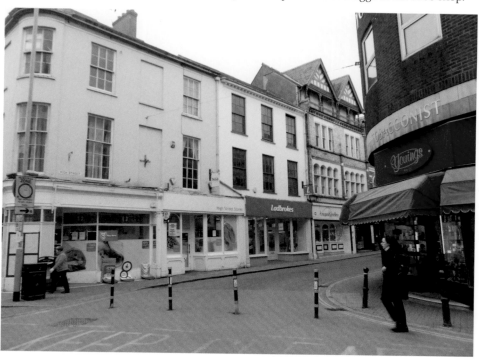

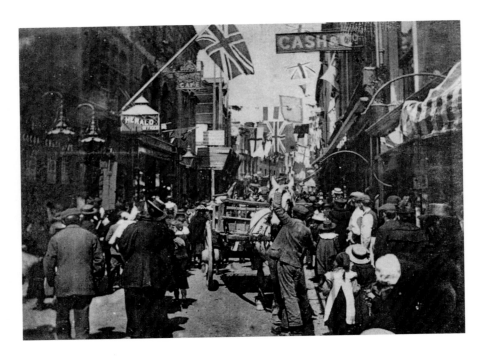

High Street VII

This photograph from 1900 shows the High Street decorated to celebrate the relief of the long Siege of Mafeking during the Boer War. To the left is the sign for the *Herald* offices. The *North Devon Herald* was first published in 1870 and amalgamated with the *North Devon Journal* (first published in 1824) in 1941. The paper was known as the *North Devon Journal-Herald* until 1986.

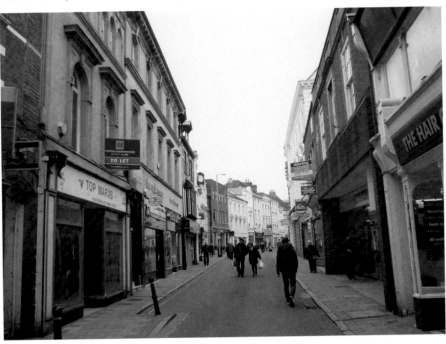

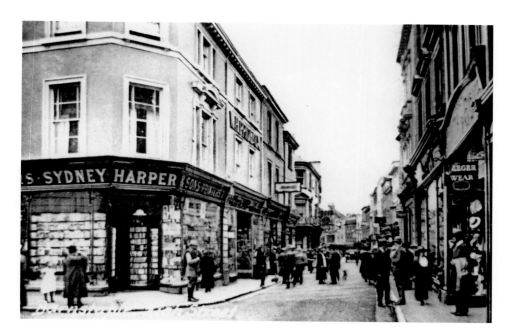

High Street VIII

On the left of this photograph from the early twentieth century is the junction of High Street with Butchers Row. The old photograph shows the corner shop of Sydney Harper, a well-known bookseller and local historian who in 1910 wrote *A History of Barnstaple for Boys and Girls*. His shop occupied the premises for many years and before that the site had been occupied by members of the Cornish family, who were also booksellers, bookbinders and printers. Since the mid-twentieth century it has changed hands several times and is now a coffee shop.

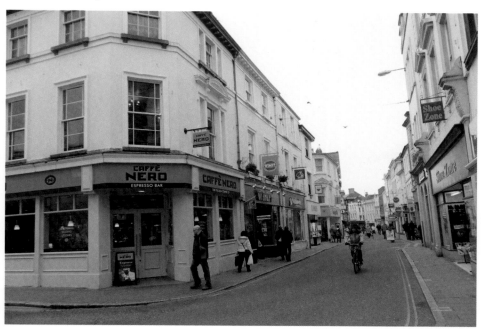

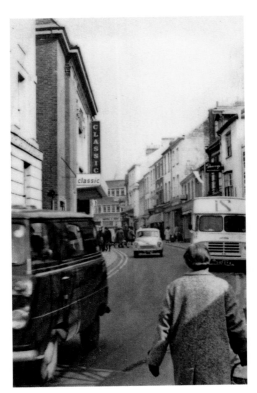

Boutport Street I

Boutport Street is a very long street, which gets its name from the fact that it developed around the outside of the old walls of early Barnstaple – 'Boutport' simply means 'about the port'. As with the High Street, many of the shopfronts have changed at ground level, but the upper floors retain their older appearance. On the left, both photographs show the cinema sign. It opened in 1931 as one of a chain of Gaumont cinemas, although the name has changed by the time of these photographs.

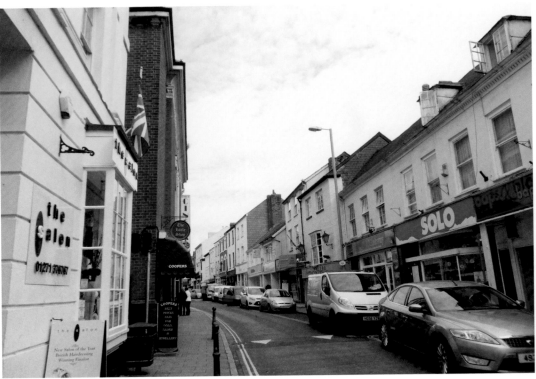

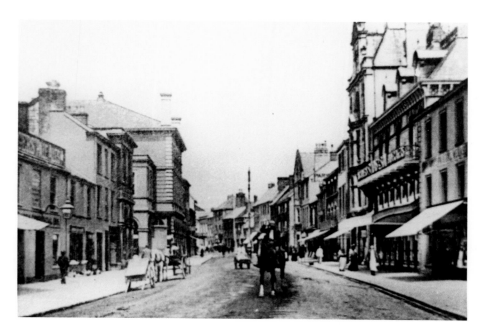

Boutport Street II

A view from further up the street. Several of the buildings in this photograph have survived with little change, except on the far right where the modern photograph shows the new buildings on the corner leading to Queen Street. Halfway along on the left is the Queen's Theatre, which has retained its façade. Originally constructed at the same time as the Pannier Market and called the Albert Hall, it was badly damaged by a fire in 1941, which left only the shell standing. It was rebuilt in 1952 and renamed the Queen's Hall.

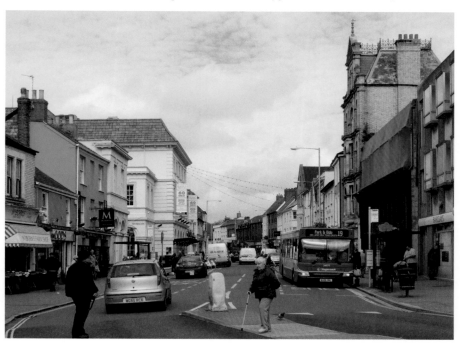

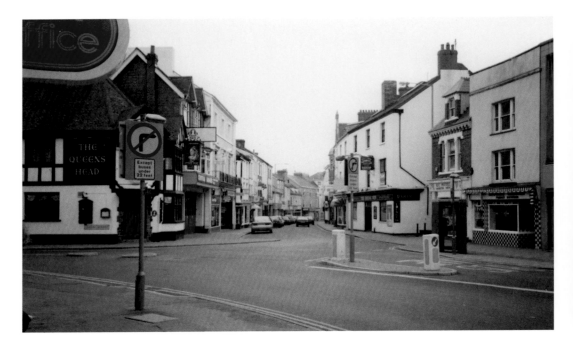

Boutport Street III

These photographs were taken from the other direction, looking towards the High Street with the turning to Queen Street on the left. The post office sign can just be seen in the top left of the older photograph which indicates it was taken after the post office had moved from the old Cross Street premises to this new building in the 1960s. On the other corner, the public house looks similar in both images, although the name has changed.

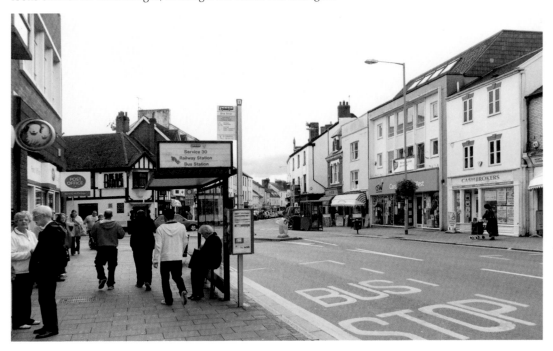

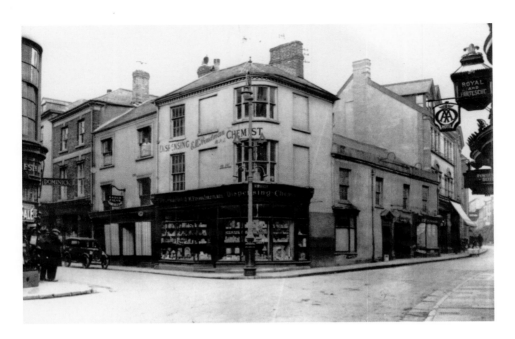

Boutport Street VI

This is the junction of the southern end of High Street with Boutport Street, photographed from outside the Royal & Fortescue Hotel, the lamp of which can be seen in both photographs. The obvious difference is the 'new' Youings building in the modern photograph, indicating that the old photograph was taken before 1934, when the new building was constructed in the latest architectural style, very different from the older buildings in the area.

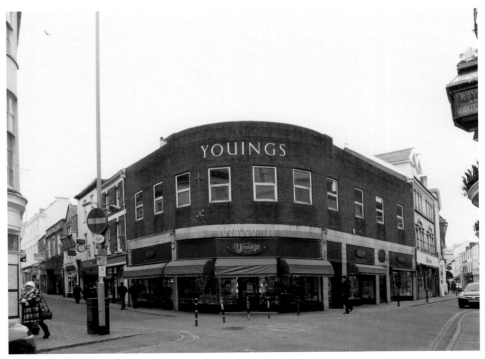

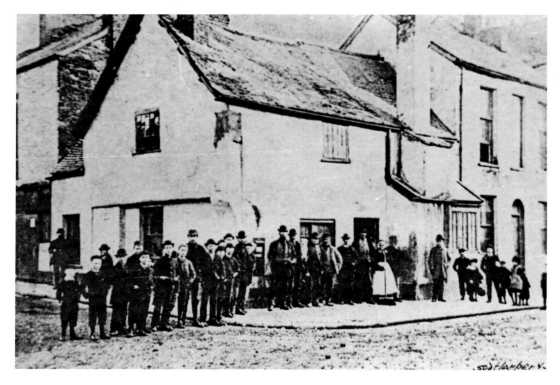

Boutport Street VII

This is one of the earliest photographs of Boutport Street, dating from around 1860. It shows the Lamb Inn at the corner of Boutport Street and Bear Street. The inn was demolished in 1885, but the house to its right is still there, with the addition of a third storey.

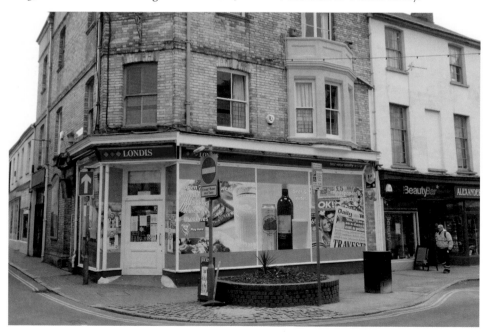

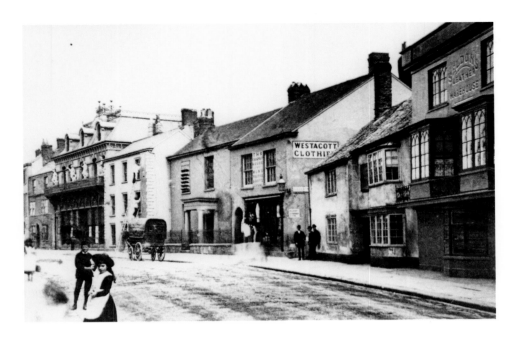

Boutport Street VIII

These photographs were taken looking in the opposite direction. They show the entrance to Queen Street on the right – in the old photograph (from around 1890) it is the narrow gap beside the Westacott clothier building. As can be seen, several buildings were demolished in the 1960s when the street was widened and the post office built. At the far left in the old photograph is a plain eighteenth-century building, which was replaced in the 1890s by the tall, more ornate building seen in the new photograph.

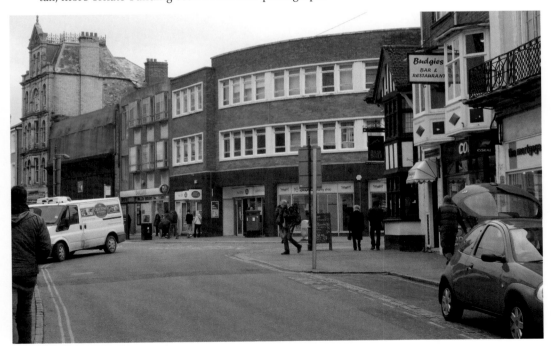

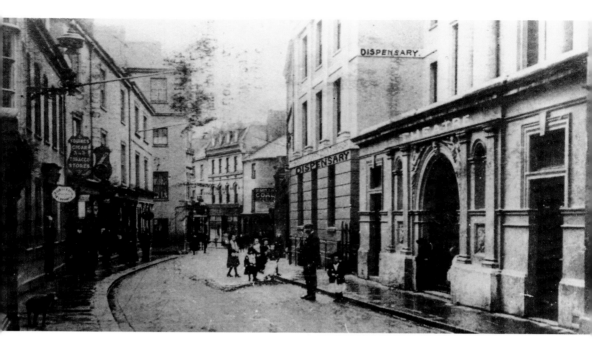

Boutport Street IX

This is a view of Boutport Street looking south towards the junction with High Street. In the old photograph, the building to the right is a theatre and the building next door a dispensary. Both of these buildings were constructed by the Bridge Trust in 1833 on part of the site previously occupied by cottages known as the Seven Drunkards, presumably because of their dilapidated condition. The theatre was leased until 1893, and then following reconstruction, it was run for many years by a committee of the Bridge Trust. In 1931 it was replaced by a cinema, which remains today.

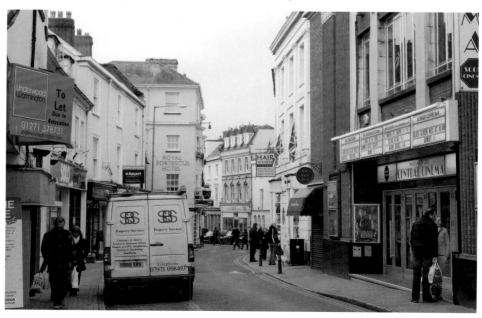

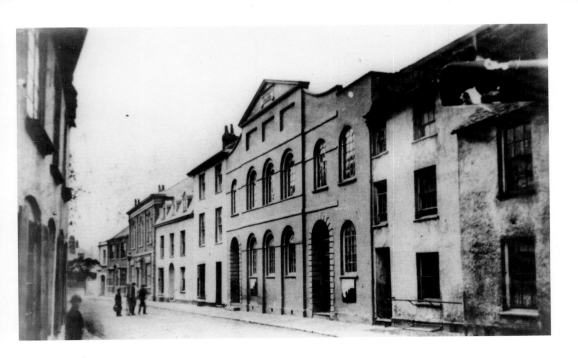

Boutport Street X

Further along Boutport Street, this photograph shows the buildings opposite what is now the rear of Green Lanes shopping centre. The main building in the 1868 photograph is the original Wesleyan Methodist chapel. It was constructed in 1867 but altered and enlarged in 1885 and 1905, all under the auspices of Alexander Lauder. Demolished in 1981, it has been replaced by Norah Bellot Court. Three doors further down are the assembly rooms of 1800. The building survives and can be seen in the modern photograph, painted blue.

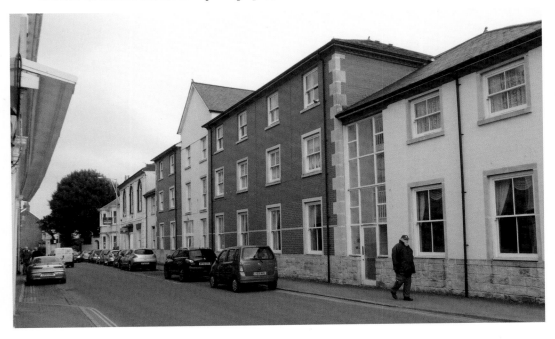

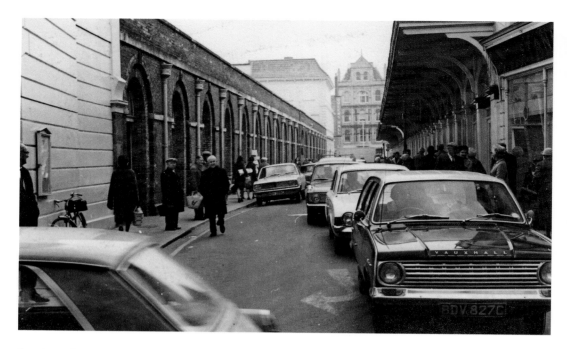

Butchers Row I

The remarkable aspect of these photographs is how little has changed in the half-century or so between them. Butchers Row and the Pannier Market on the left were constructed in 1855/56. For centuries Barnstaple's market was held in the open streets, but by the 1850s the town was growing, and it was decided that a covered space was required. Although at the time many were opposed to its construction, it is still in use for its original purpose over 150 years later. The market is built on to the Guildhall, which dates from 1826 and part of which is visible on the front left of the picture.

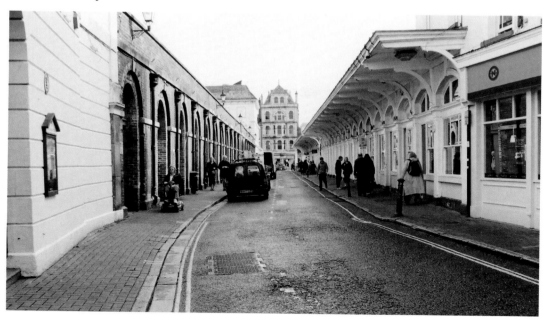

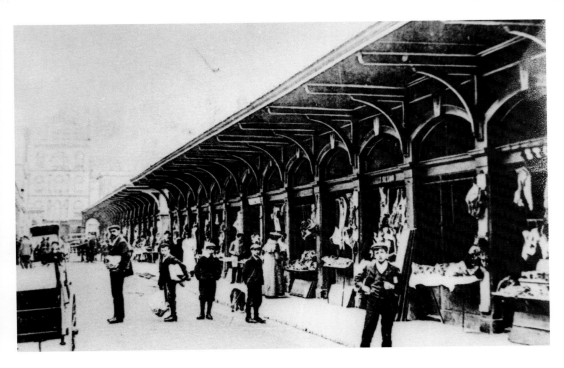

Butchers Row II

This photograph of Butchers Row, from around 1910, clearly shows the butchers' shops, which were the only type of shop permitted here until the Second World War, when meat was in short supply and other food shops were allowed to trade in the row. At the far end can be seen one of the arches that stood at either end until the 1960s. Otherwise little has changed, except the form of transport and the style of clothes.

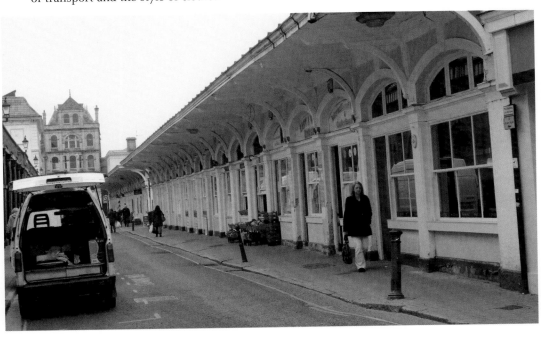

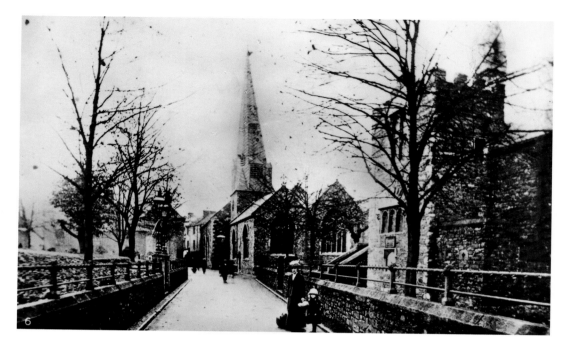

The Churchyard

Although taken around a century apart, these photographs show little change here in the churchyard in the centre of Barnstaple. They are taken from the Boutport Street end, looking towards the High Street. The railings on top of the wall have gone, but St Anne's chapel on the right and the parish church in the centre look as they have done for centuries. Some of the trees in the old photograph seem to be the same, except they have grown a bit larger over the years.

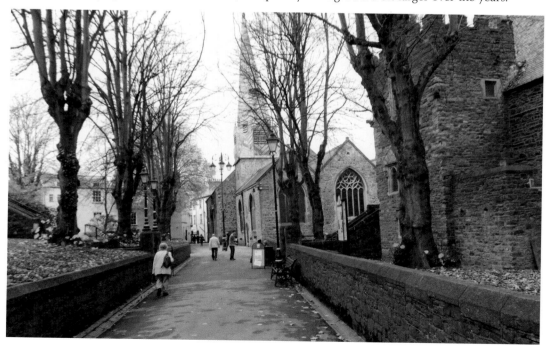

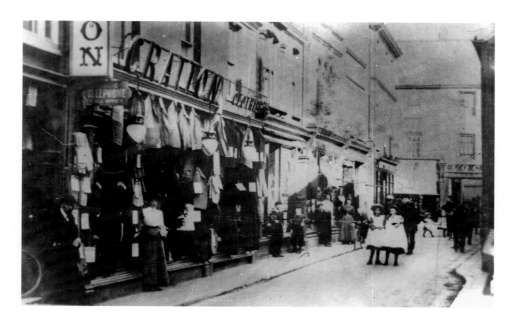

Joy Street I

Joy Street is an old street, and for centuries was the only road through from High Street to Boutport Street. Archaeological excavations in the 1970s revealed traces of eleventh-century buildings. Remarkably the street frontage then only varied by about 12 inches from the present line of the buildings. In the fifteenth century, Joy Street was known as Eastgate Street, a reference to the east gate, which once stood at the Boutport Street end. The new name was in use from at least 1578 and may relate to a family called Joy or Joye who lived there.

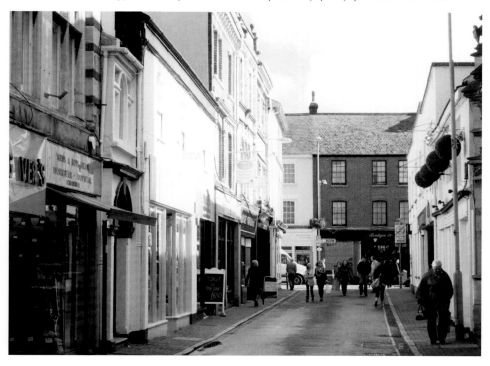

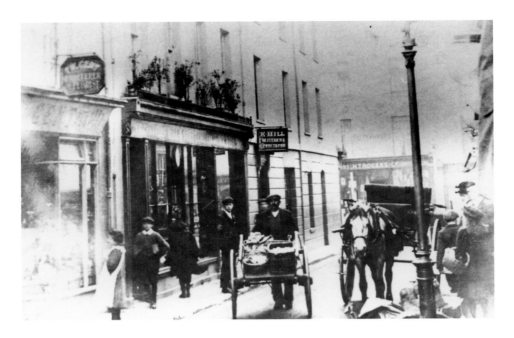

Joy Street II

These photographs are taken looking towards the High Street. Many of the old buildings in Joy Street have been replaced, either completely or partially, and their occupants have changed often, even in recent years. One of the businesses that survived in the same family for a considerable time is seen in the old photograph. The sign announces that R. Hill was a fruiterer and confectioner, but the family occupation soon changed and the firm is best remembered now as a watch repairer and jeweller.

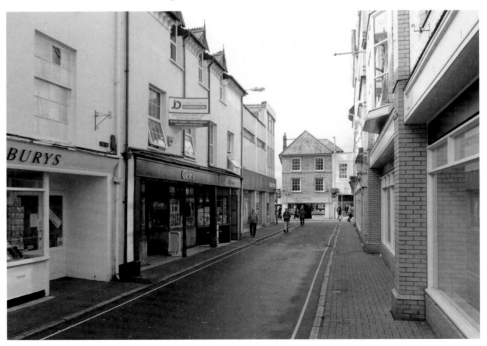

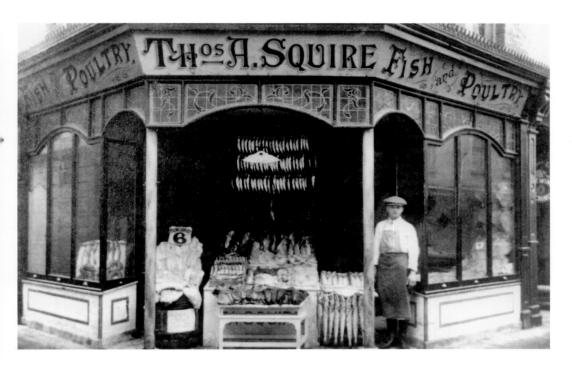

Joy Street III

These photographs show the shop on the corner of Joy Street and Market Street, which was known until the second half of the nineteenth century as Anchor Lane. In the hundred or so years between the images not a great deal has changed. Then it was occupied by a seller of fish and poultry and now it is occupied by a butcher. Although the windows have changed, the overall appearance of the building remains the same.

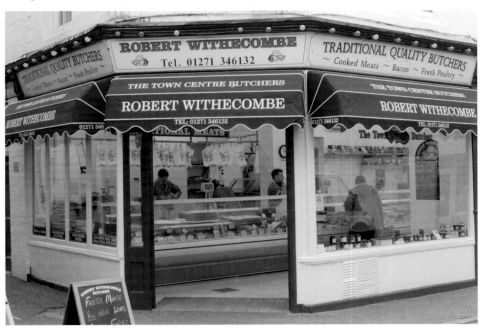

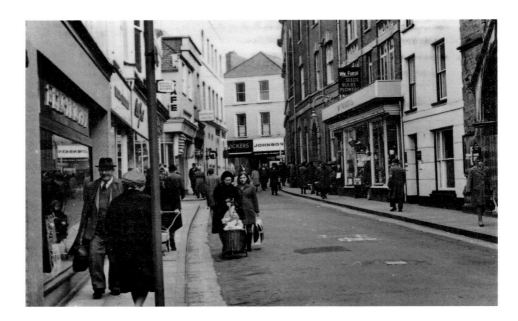

Cross Street I

The buildings in both these photographs, taken perhaps fifty years apart, look much the same, but the shops and businesses occupying them have all changed. The building on the extreme right, only part of which is visible, is the Congregational church of 1870. The first Congregational church in Barnstaple was in Holland Street in the 1660s, but there has been one in Cross Street since the early eighteenth century. This building was designed by R. D. Gould and his son J. F. Gould, who worked with his father but died prematurely in 1881. The building is now used as an antiques centre.

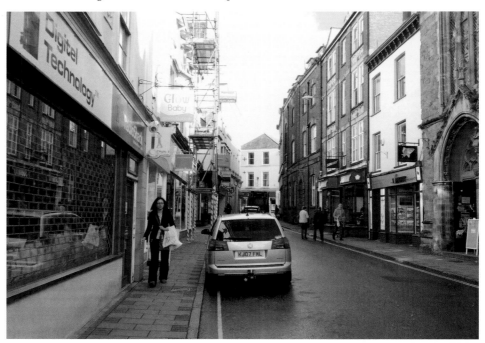

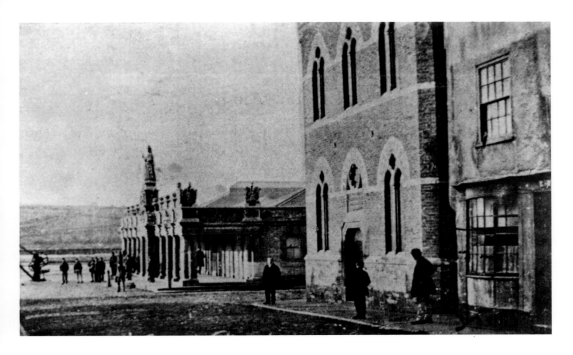

Cross Street II

Until around the middle of the seventeenth century, Cross Street was known as Crock Street (or various spellings thereof), probably because it was the site of the potters' market. This old photograph dates from before 1894, as it shows the first version of the Congregational schoolrooms on the corner with the Strand. The later version, from 1894, is seen in the recent photograph, although the ground level of the building has been greatly altered.

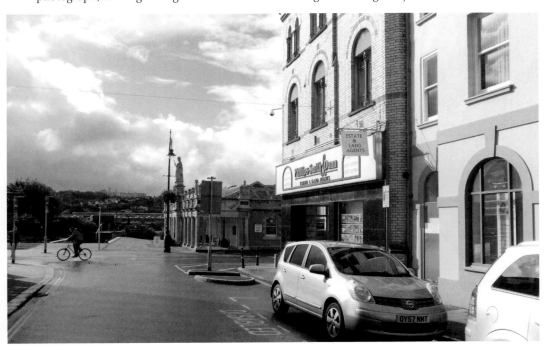

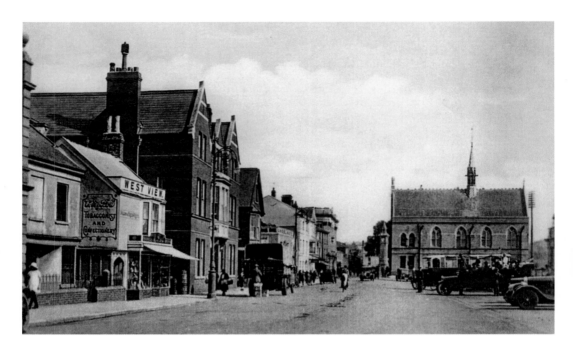

The Strand I

The name 'Strand' refers to a shore, in this case the shore of the River Taw where Barnstaple was established. For many centuries the town was an important port, and the Strand would have been as busy as the High Street. Although there have been many changes here, Bridge Chambers is clearly visible in both photographs, obscured behind the trees in the modern picture. The Gothic style of architecture means that the building is often mistaken for a church, but in fact it was built by the Bridge Trust in 1874 as offices and a public hall.

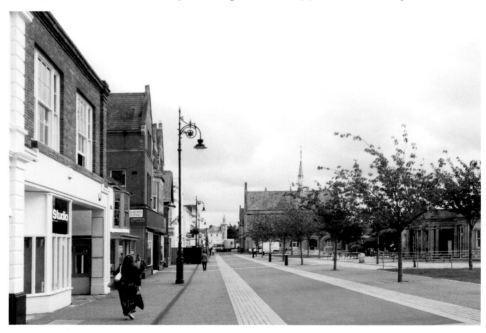

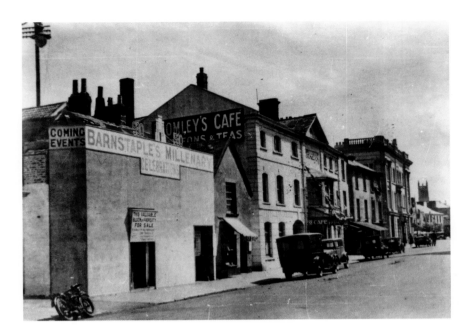

The Strand II

This photograph of 1930 is advertising coming events connected to the Barnstaple millenary celebrations of that year. The advertisement is fronting the site of the old Angel Hotel, where the Regal cinema would be built. The building next to it (the Water Gate in the modern photograph) is Bromley's Café, fondly remembered by many who lived in the area during the middle years of the last century. The building went from High Street through to the Strand and at busy times the ballroom at the Strand end became an extension of the café.

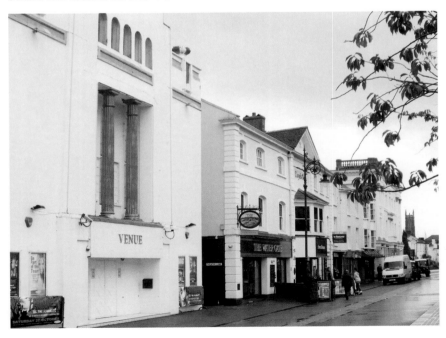

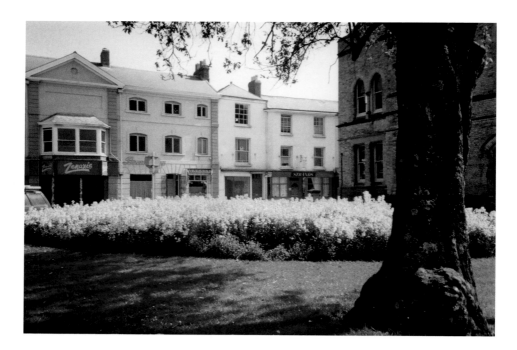

The Strand III

Another view of the Strand before the alterations of recent years. Both photographs show the side of Bridge Chambers on the right, but the flowers in the foreground of the 1980s photograph have been replaced by the fountain. Bromley's had closed by the 1980s and the building is occupied by Zenaxis in the old photograph. The other buildings have also changed hands, but look much the same apart from a change of colour.

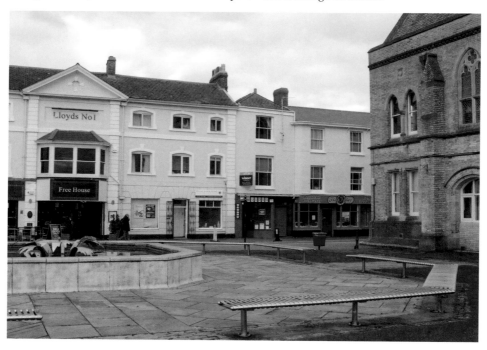

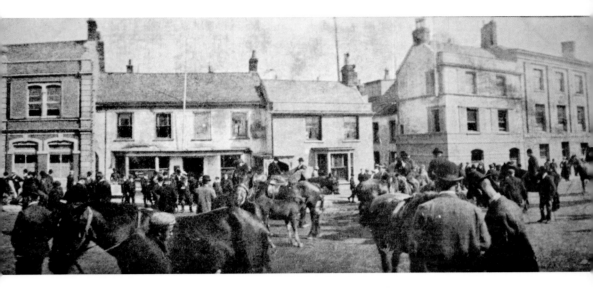

The Strand IV

A photograph from 1904 shows the Strand being used for the Horse Fair, an annual event held as part of the town's ancient fair. The building in the middle, now a restaurant called the Custom House, has been through many changes. In the 1904 photograph it is a private property, but in the previous photograph, from the 1920s, it is clearly visible as West View stores, which it remained for most of the twentieth century. As the modern name suggests, in the seventeenth century it was a custom house. In the forefront of the modern photograph is a corner of the Millennium Mosaic, constructed in 2000 as part of the Millennium celebrations.

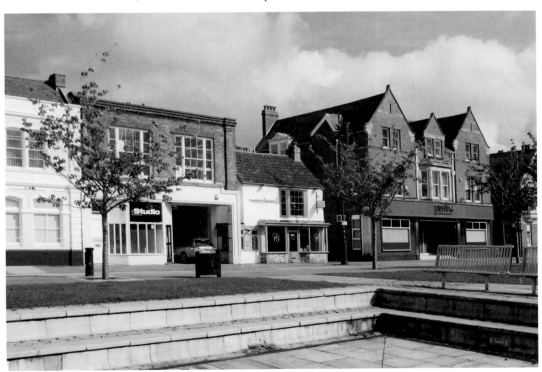

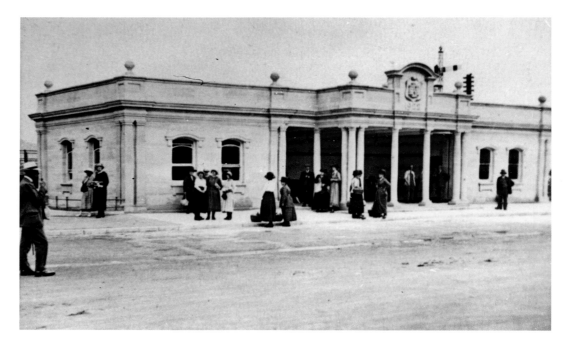

The Strand V

Although there are more than seventy years between these two photographs, they appear almost identical apart from the tables outside and the glass between the entrance columns in the new photograph. The building dates from 1922, when there were major alterations to this area. This was the bus station, and it continued in use until it was replaced in 2000 and the building became a café.

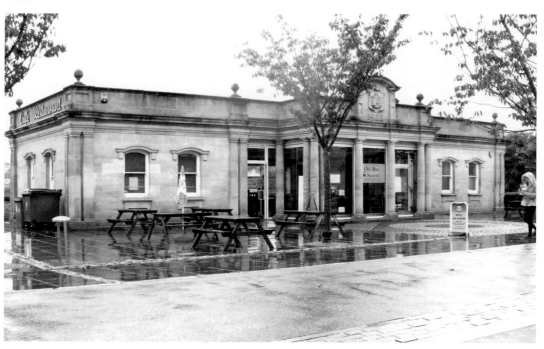

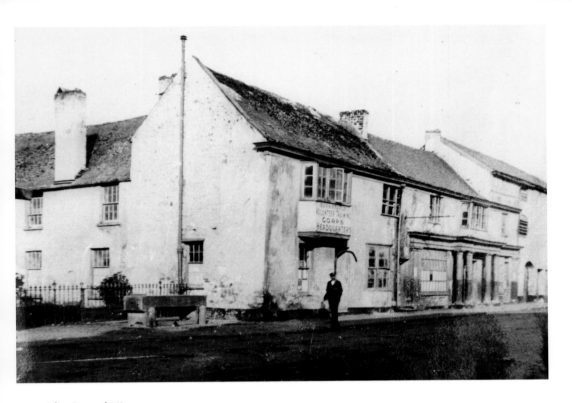

The Strand VI
Another photograph taken before the major alterations of the 1920s, when the bus station was built on this site. These buildings were next to the Fish Market and the building in the centre was the headquarters of the Barnstaple Voluntary Training Corps, originally formed in 1859, when there was a feeling that the community should be able to defend itself. The horse trough was taken to the Cattle Market and then to the new library site.

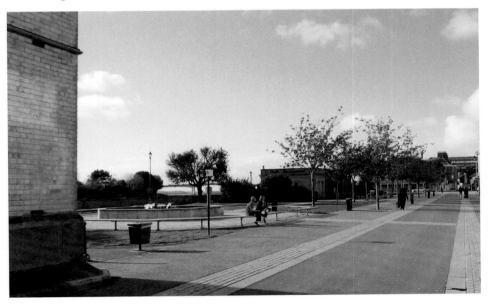

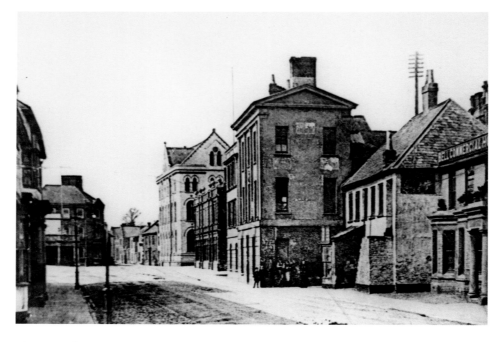

The Strand VII

This photograph must date from between 1894, when the schoolrooms were rebuilt, and 1922, when the bus station and gardens replaced the buildings on the left. The one building that appears in all the photographs of this area is Queen Anne's Walk, the end of which is visible opposite the schoolrooms. Built in the early eighteenth century, long before photography, its appearance is hardly changed.

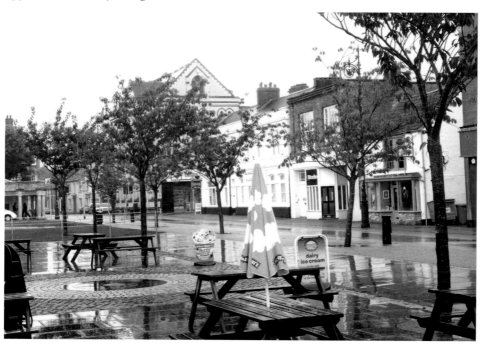

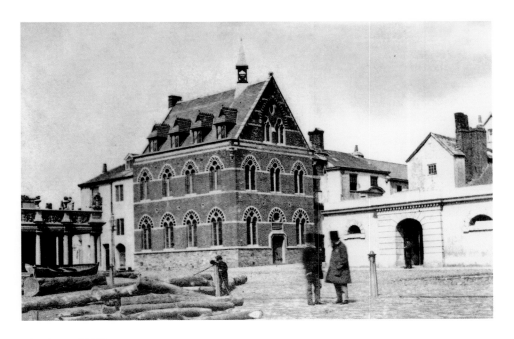

The Strand VIII

This is one of the earliest photographs, probably dating from the 1860s. Although the large building on the left corner of Cross Street appears similar in both old and new photographs, the modern one shows the rebuilding of 1894. The old photograph shows the original Congregational Church schoolrooms of 1854, designed by R. D. Gould and erected on the site of dilapidated buildings known as Rat's Castle. R. D. Gould was Borough Surveyor for fifty years and designed most of the Victorian buildings we see today in Barnstaple. The west gate stood at this end of Cross Street and the arch had only been demolished in 1852.

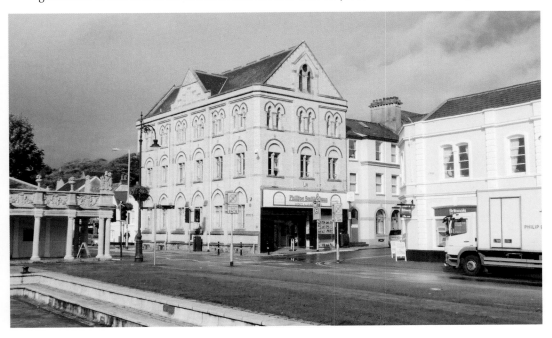

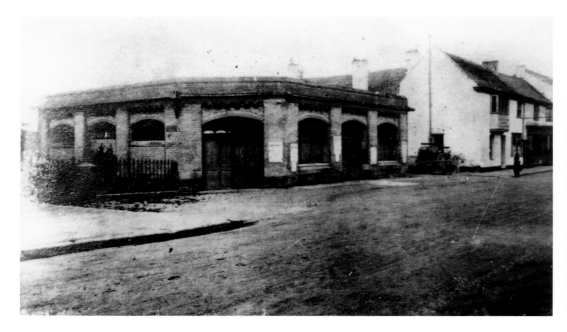

The Strand IX

Taken before the major alterations of the 1920s, there is nothing in this old photograph that is recognisable today. It shows the Fish Shambles or Market, dating from 1873, which replaced an earlier Shambles that was demolished when the railway arrived on this side of the river. It did not do well and was closed in 1896. The fountain was part of the redevelopment of the riverfront in 2000 and was placed on the site of the Fish Shambles.

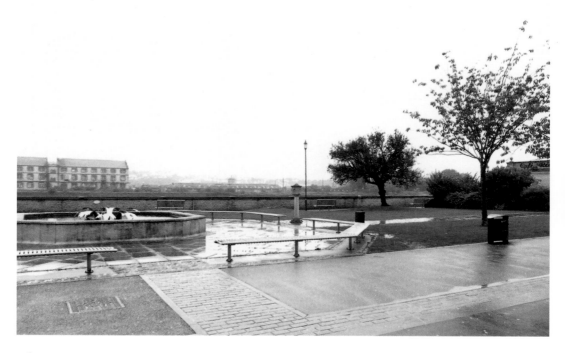

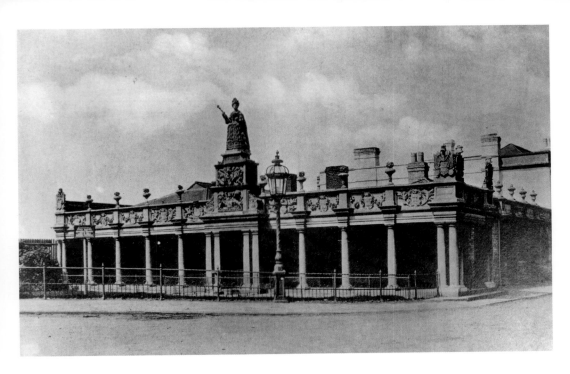

The Strand X

Barnstaple had become such an important port that in 1555 the 'maisters of the towne' petitioned Mary Tudor to allow a 'great quay' and merchants' exchange to be built along the riverfront. The first colonnade – known as the Merchants' Walk – was rebuilt in the early 1700s and renamed Queen Anne's Walk after a statue in honour of the sovereign was added by Lord Rolle. The exterior has been unchanged over the centuries and now houses Barnstaple Heritage Centre.

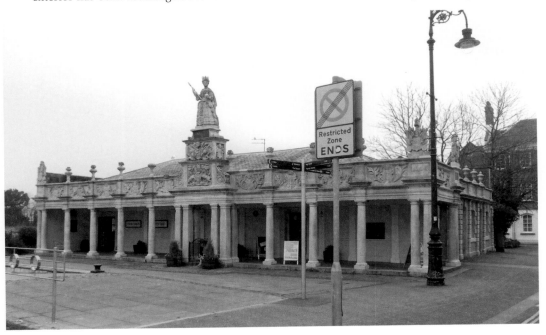

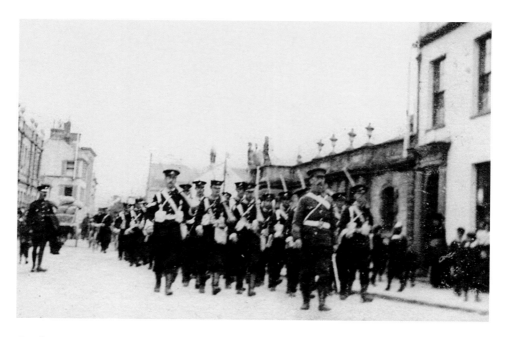

Castle Street I

This photograph shows what is believed to be a military parade at the end of the Boer War, which began in 1899 and ended in 1902. The parade is passing Queen Anne's Walk and the familiar outline of Bridge Chambers is visible in both photographs – behind the trees in the recent photograph and behind the soldiers in the old photograph. Prominent in the modern photograph are the traffic lights and other traffic signs.

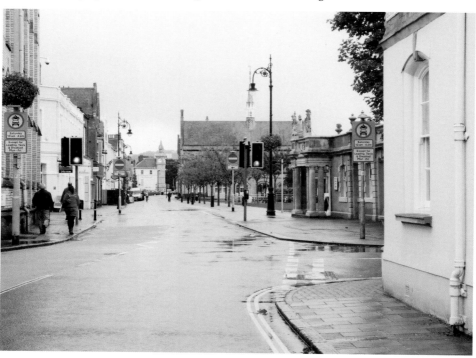

48

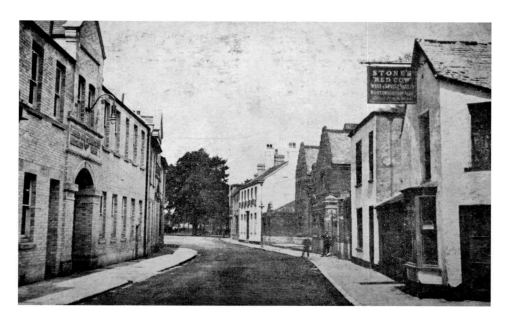

Castle Street II

Clearly visible in this old photograph is the sign 'Stone's Red Cow', a public house on the corner of Holland Street that was demolished in 1912. Presumably the name is a reference to the famous red ruby Devon cattle. Further down on the right is the archway leading to Barnstaple's last prison, built in 1874 adjoining the Cattle Market. However, it was only in use for four years; after 1878 prisoners had to be sent to Exeter Gaol. The exercise yard of the prison became part of the Cattle Market.

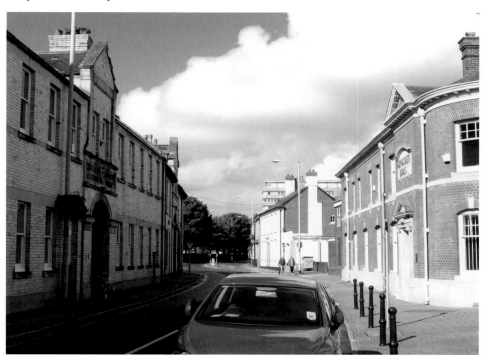

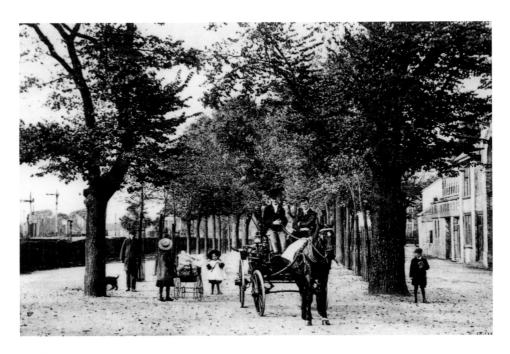

Castle Street III

This old photograph is clearly posed to create an attractive image, as the carriageway is actually on the right. North Walk was first laid out in the mid-eighteenth century, when the town was growing and becoming more elegant. As with the Square, muddy riverbanks were being changed into places to walk and take the air. The area has changed considerably since then, with the modern photograph being dominated by the civic centre and the old telephone exchange.

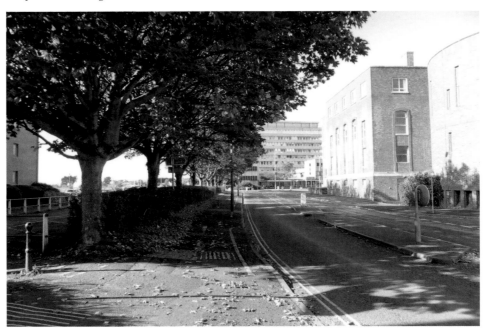

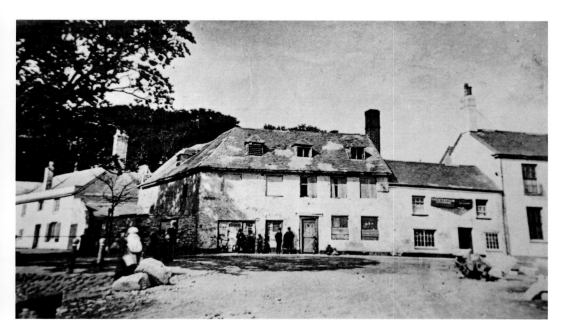

Castle Street IV

This area looks very different now, although the house on the far right appears the same. The corner building in the early photograph is the Castle Inn, which appears to be boarded up prior to demolition. It was replaced by another public house, which has had various names, the latest being Monkey Island. That name refers to the artificial lake and island created in the nineteenth century where the civic centre stands today. Its official name was Cyprus Island, but it was nicknamed Monkey Island, possibly because the architect, R. D. Gould, was supposed to resemble a monkey.

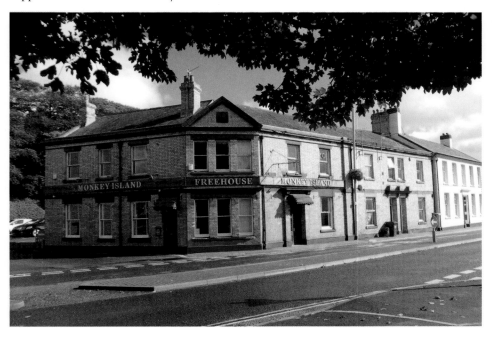

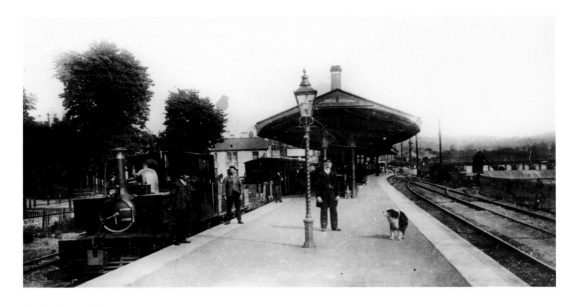

Castle Street V
Another part of old Barnstaple that has vanished. The first railway station on the town side of the river was on the site of the old bus station (now a café). This photograph shows the later town station from 1898, when the railway went to Lynton as well as Ilfracombe. Although the façade of the station is visible on North Walk, the railway lines are long gone.

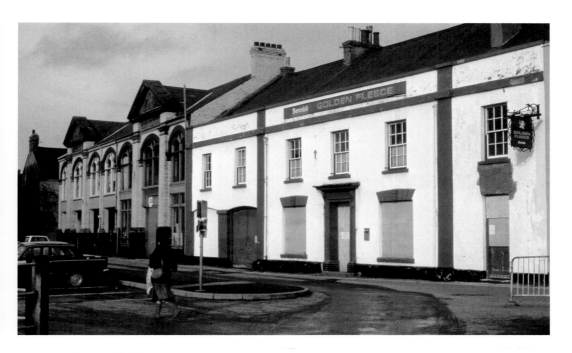

Castle Green/Tuly Street I

These photographs also show the Golden Fleece building. It was built in the first half of the nineteenth century by the Bridge Trust and sold by them in 1922. Next to it is the Squire & Son building. Both of these buildings have retained their original appearance, although no longer used for their original purpose. An arched entrance to the Cattle Market used to stand opposite the Golden Fleece, with the date 1848. Although various animal markets had been held in the town for centuries before this, it was on this date that the Cattle Market was opened.

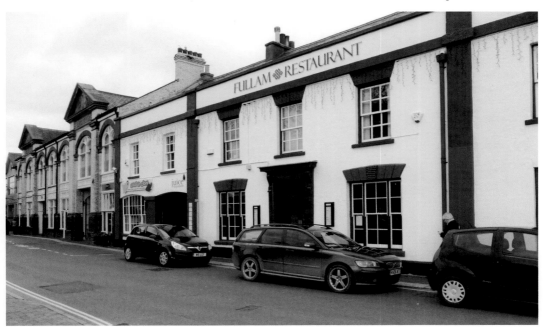

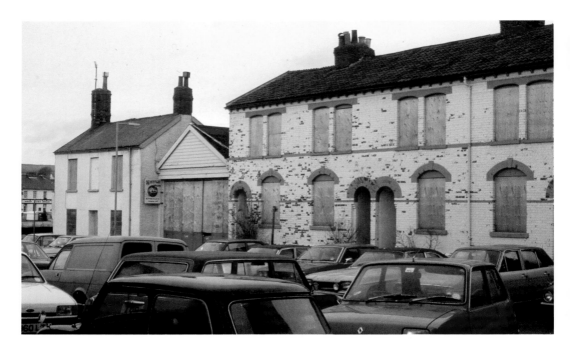

Castle Green/Tuly Street II

Although this photograph was probably taken at the same time as the previous two, in the early 1980s, there is nothing to link it to the modern photograph. The houses at this end of Tuly Street were completely demolished to make way for new shops, offices and a supermarket car park. Tuly Street was long spelt Tooley Street, and the name is said to be a corruption of St Olave, the street being named for the nearby St Olave's Well.

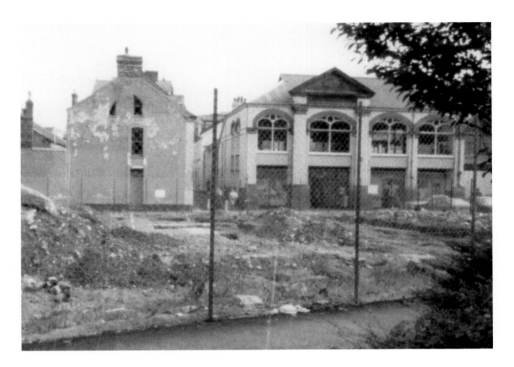

Castle Green/Tuly Street III

This photograph was taken in the 1980s, when the old buildings had been demolished to make way for the new library. This area has changed greatly, but both photographs show the façade of the Squire & Son building. Dealers in agricultural machinery and implements, Squire & Son had begun trading in 1875. Their High Street premises extended to a garden in Tuly Street, and in 1903 they built new showrooms here, designed by Alexander Lauder, who was also responsible for the terracotta panels showing ploughing and reaping.

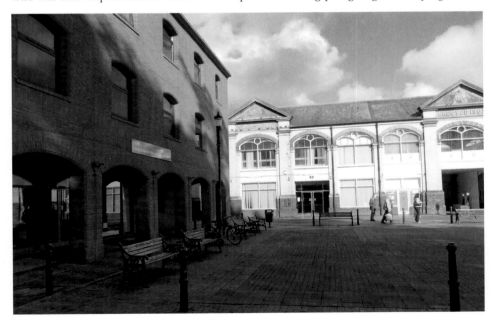

Castle Green/Tuly Street IV
Another view of the old Dornat's factory and the new library, which opened in 1988. The new building also houses the North Devon Record Office. Previously all records were held at Exeter, which meant a lot of travelling for anyone wishing to consult original documents. The North Devon Athenaeum collection of books was also moved here. Just visible to the right in the old photograph and more clearly in the new photograph is the Golden Fleece public house, now a Chinese restaurant.

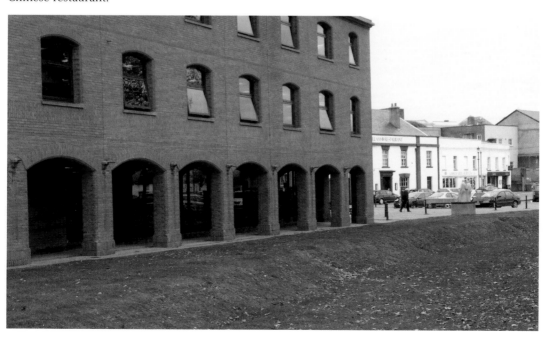

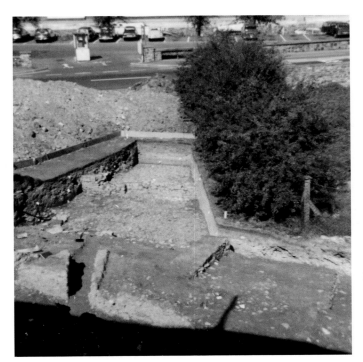

Castle Green/Tuly Street V
This is another photograph from the 1980s, when archaeological excavations were carried out in the area. This picture is looking across the road to the other side of the River Yeo, although the water cannot be seen. As with the Taw, the Yeo once flowed over a much wider area and probably formed the boundary of the castle bailey, long before North Walk existed.

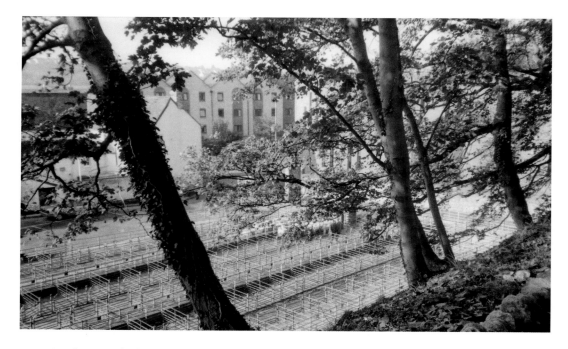

Castle Green/Tuly Street VI

These photographs show an unusual view of the area. They were both taken from near the top of the castle mound, a very good viewing point from which to look over the town. Although the earlier photograph is comparatively recent, dating from 1990, it demonstrates one of the major changes over the last twenty years. It shows the animal pens associated with the Cattle Market, which closed in 2001. The area is now a car park.

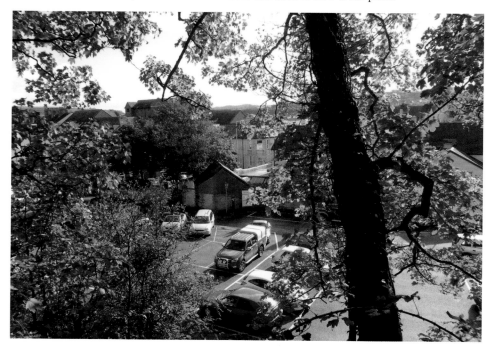

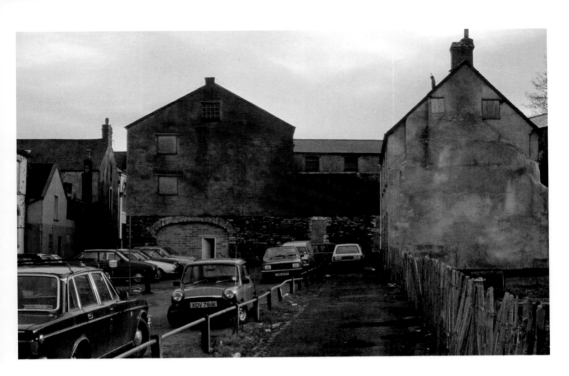

Castle Green/Tuly Street VII

The old buildings are shown in this photograph before demolition, with the modern photograph showing the library car park and the rear of the library building that now occupy the site. The buildings were part of the Dornat's mineral water works, which operated on the site from about 1870 until 1980, when Richard Youings, a descendant of the Dornat family, retired. There were plans to convert the buildings for use as an entertainment centre, including an ice rink, but eventually the old buildings were demolished and the library constructed.

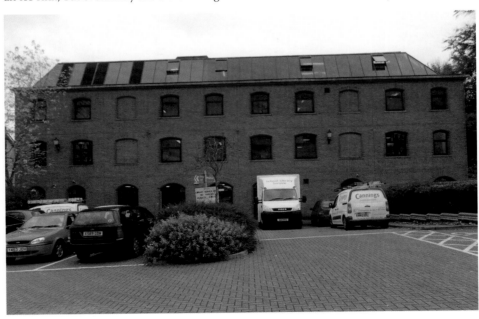

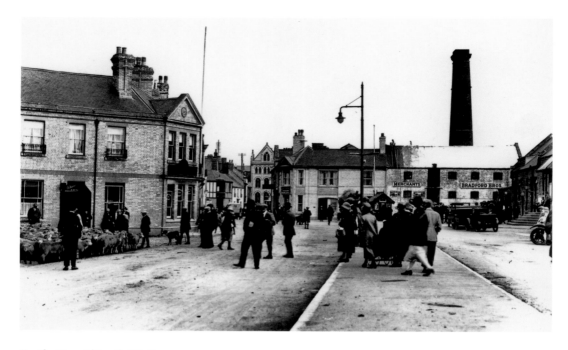

Castle Street/North Walk

Unusually, this photograph was taken looking towards Cross Street. The Congregational school building can be seen in the distance, near the centre of both photographs. The buildings on the right of the old photograph have been replaced, but the public house on the left is still there. The chimney in the older photograph belonged to the borough electricity works and was 80 feet high. Just out of sight to the right is the old town station.

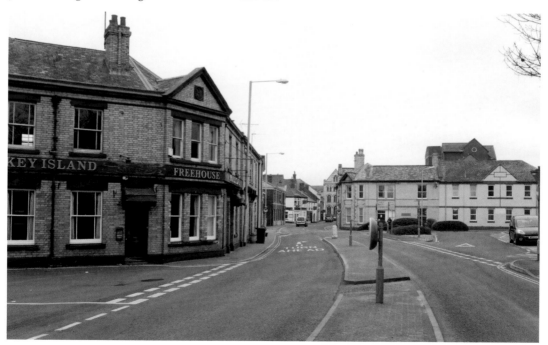

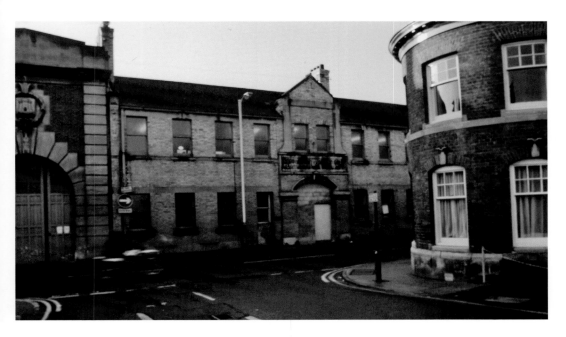

Castle Street

Looking towards Castle Street from Holland Street, these photographs show the 'borough of Barnstaple electricity works', as the inscription on the building proclaims. These were opened in January 1903 and supplied Barnstaple with its electricity until Yelland power station was built in the late 1950s. When power was first produced, only seventy houses were connected to the system, although this soon increased. The building to the right of Holland Street was part of the old police station before the force moved to the civic centre.

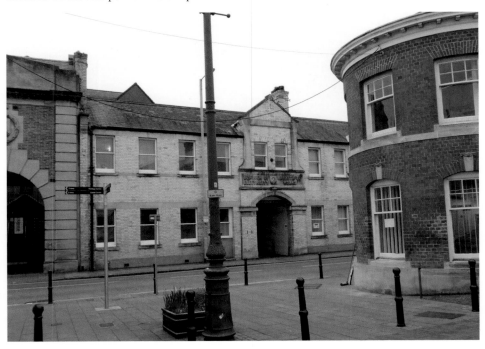

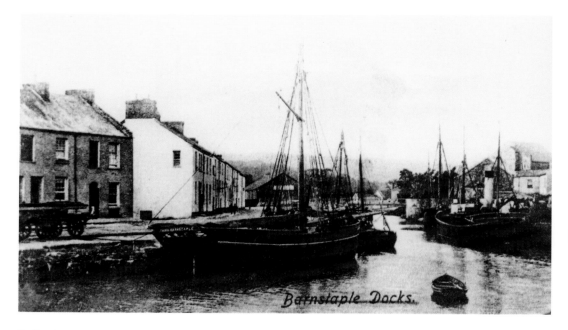

Barnstaple Docks.

Rolle Quay I

This old photograph, labelled Barnstaple Docks, makes it clear that it was taken when Rolle Quay was a thriving working dock area. The recent photograph shows more cars in the car parking area behind the modern wall than ships in the river. The quay closed in the 1960s, marking the end of Barnstaple's long history as an important port. Some of the old cottages are still in use after renovation, but, in contrast, on the far left of the new photograph can be seen a modern block of flats.

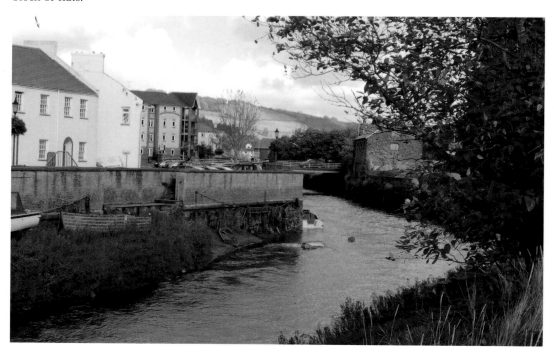

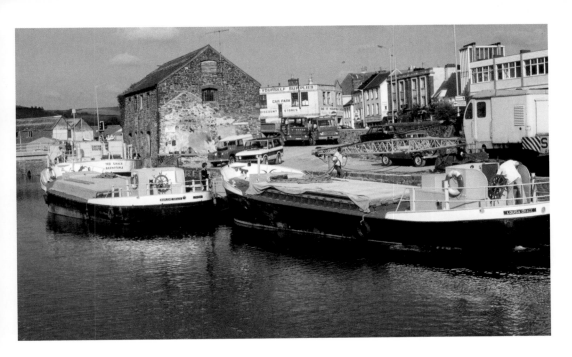

Rolle Quay II

This photograph shows barges unloading sand or gravel at Brunswick Wharf. The old builder's warehouse is still there, although now unoccupied, but the major difference again is the lack of shipping in the modern photograph. The trading life of the quay was comparatively short, as this area was not developed until the mid-nineteenth century, after the building of a road and swing bridge connecting the Pottington area with the northern end of Barnstaple.

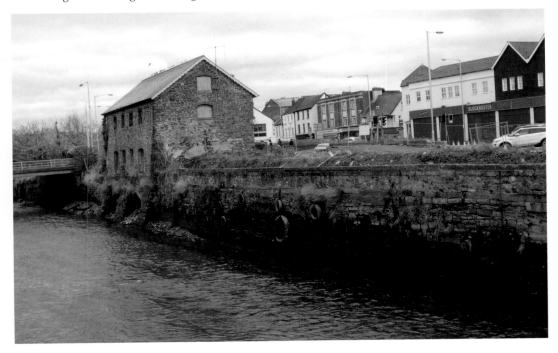

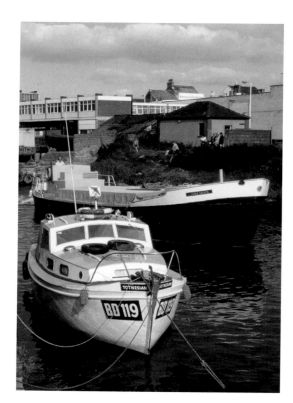

Rolle Quay III

The earlier photograph shows the River Yeo at the end of its working life. Boats came and went with cargos of agricultural produce and animal feed, with sand barges going up to local builders' merchants William Gould & Sons, of Northgate House. The sand barge Louisa Grace, owned by Terry Grace, can be seen. At one time, loading and unloading was possible by a small railway line. It is noticeable in the later photograph how empty the river now is, except for one lonely rowing boat. To the right can just be seen the library, built in the 1980s.

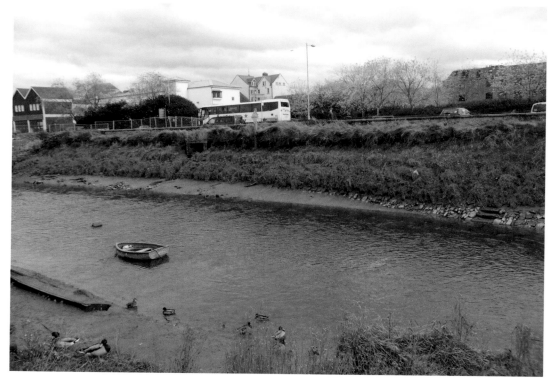

Rolle Quay IV

These photographs both show Rolle Street, and it would seem little has changed except for the style of the street lighting. The houses were built in the late nineteenth century, probably with bricks from the Alexander Lauder & W. O. Smith brick-making business, established in 1876 on land behind Rolle Quay. Both the street and quay bear the name of the Rolle family, who had owned land in Pilton and Barnstaple for centuries, and who, by the late nineteenth century, were the most prominent landowners in Devon.

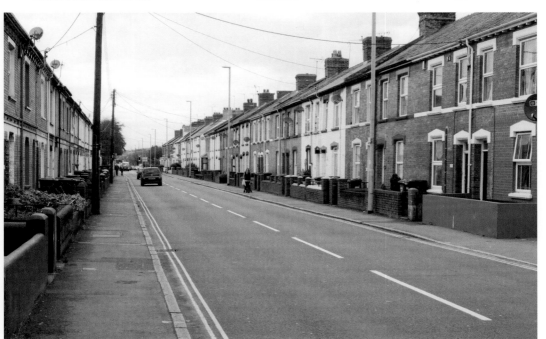

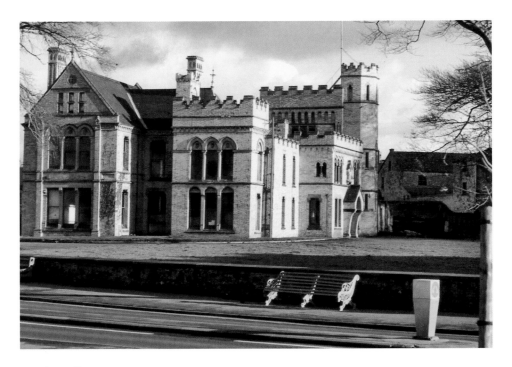

North Walk

This old photograph shows Castle House, always known locally as 'the Castle'. A Victorian building, it was occupied by the last private owner of this area, Mr W. P. Hiern, a famous botanist who catalogued the botanical sections of the British Museum library. During his ownership, large greenhouses were constructed against the walls of the house. Following his death the house was purchased in 1926 by Barnstaple Borough Council for use as offices. It was demolished in 1976 to the lasting regret of many older residents.

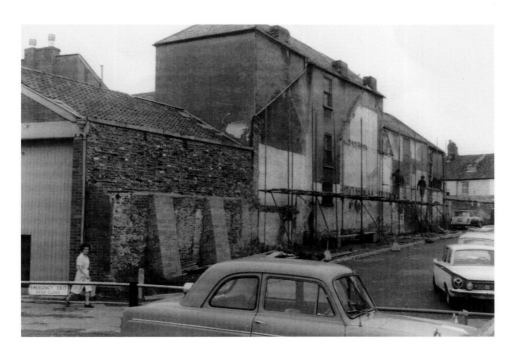

Silver Street I

This photograph, taken in the 1960s, shows Lewis & Sons, North Devon's oldest established removal and storage contractor. Established by William Lewis, the three-times great-grandfather of Simon Lewis, the present owner, it has been operating from the same Silver Street premises since 1835. The company's present fleet of modern, purpose-built vans are a far cry from the horse-drawn wagons it would originally have used. Looking down Silver Street, to the left the Albert Inn (now the Tavern) can just be seen.

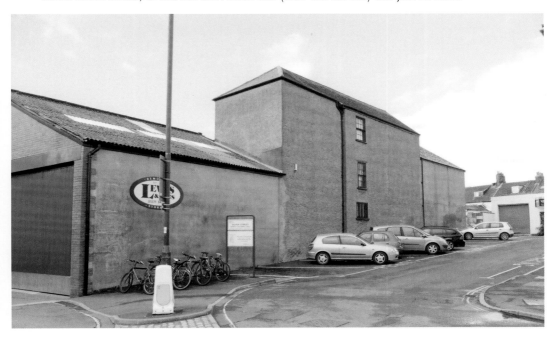

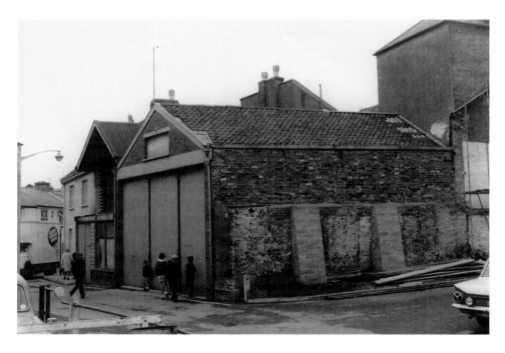

Silver Street II

A slightly different view from that above, here we see the point where Silver Street leads onto Wells Street. To the right of the older picture, Moxhams Court can just be seen. The current bus station is directly opposite. The earlier photograph shows how the row of shops and houses here had just been demolished, with the builders still clearing up.

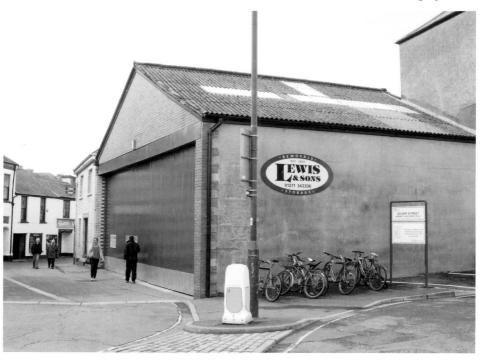

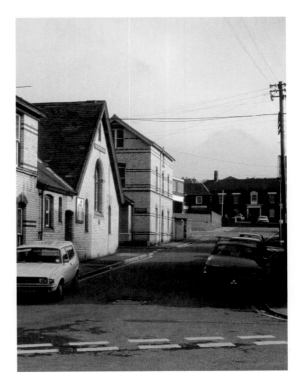

Buller Road
Another part of the area altered by the inner relief road. The earlier photograph shows the old headquarters of the Salvation Army, now demolished. In both photographs, the Territorial Army headquarters in Oakleigh Road can be seen in the distance.

Summerland Terrace

This shows Summerland Terrace, now opposite the bus station. In the older photograph, the property to the left was occupied by F. E. Norman estate agents. It was later the local offices of a television company but is now empty. This area was developed in the second half of the nineteenth century on what had previously been meadows and brickfields. In the later twentieth century it was much altered again by the inner relief road and the new bus station.

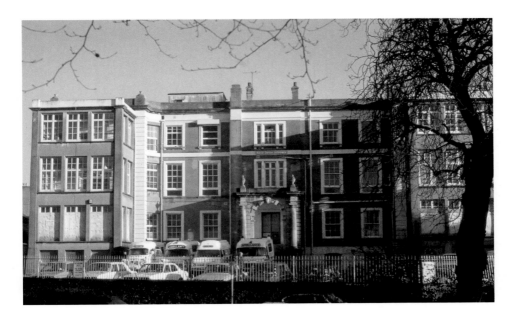

North Devon Infirmary, Litchdon Street

The North Devon Infirmary was built by public subscription, following a meeting in 1824 at which £1,059 was raised and many annual subscriptions promised. The site was acquired in 1825, and the twenty-bed hospital opened to its first patients in August 1826. In 1828 a wing was added for 'offensive or infectious patients' and further wings were added in 1862 and 1883. It closed in 1978 upon completion of the new North Devon District Hospital, or 'Pilton Hilton' as it was known locally. The buildings were demolished and the Barum Court flats built on the site.

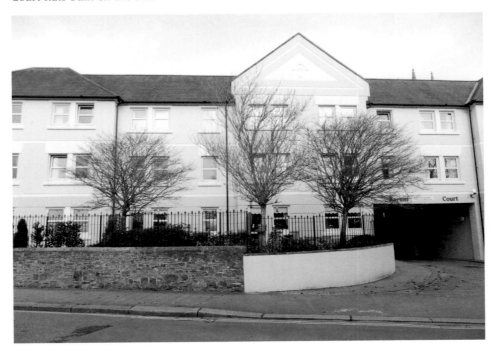

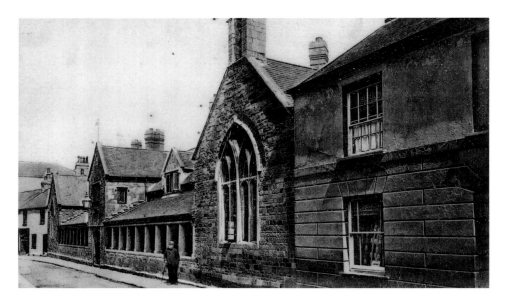

Litchdon Street I

These photographs are of the Penrose Almshouses, erected in 1627 in accordance with the bequest of John Penrose, one of the wealthy merchants who lived in Barnstaple around that time. Although they have been restored and modernised over the years, their appearance has changed very little. The entrance is in the centre of a colonnade with granite pillars. There is a chapel at one end, with a bell above, and a meeting room at the other end. There were originally twenty dwellings for two people each, although now some have been altered to provide single accommodation.

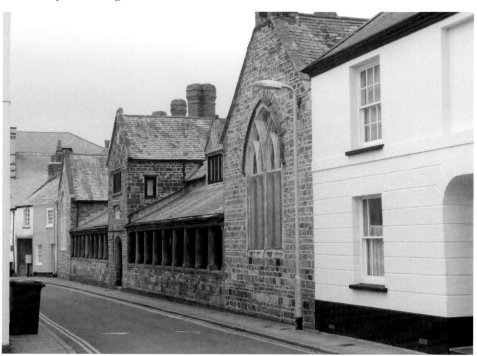

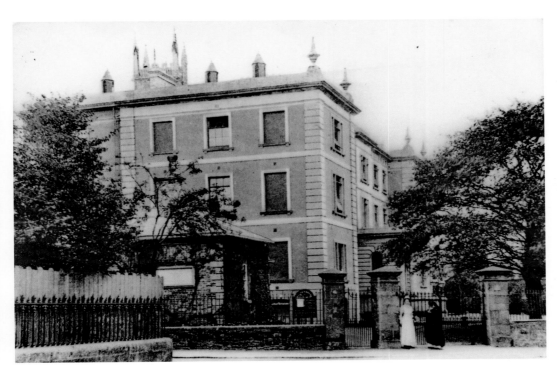

Litchdon Street II
Another view of the North Devon Infirmary from the late nineteenth or early twentieth century.
The tower of Holy Trinity church can be seen behind the building, almost hidden by trees in the
modern photograph.

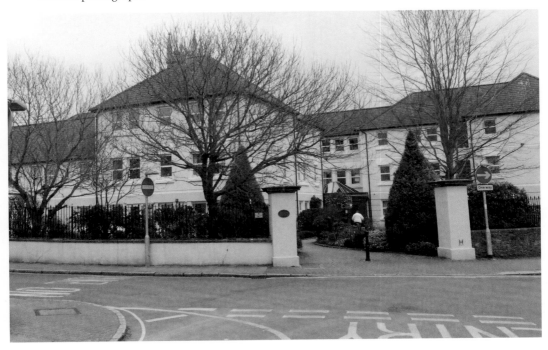

Litchdon Street III

These photographs are taken from just beyond the almshouses looking towards the Square. In the earlier picture, taken around twenty years ago, the Exeter Inn is a thriving public house, its name deriving from its position on what was the main road to Exeter. Although the frontage remains the same, the inn has closed and residential accommodation has been built on the site; its name, Exeter Inn Court, alludes to the old pub. Just beyond the inn can be glimpsed the Brannam's pottery building, constructed in 1886 at the height of its success, but now just a façade with new occupiers.

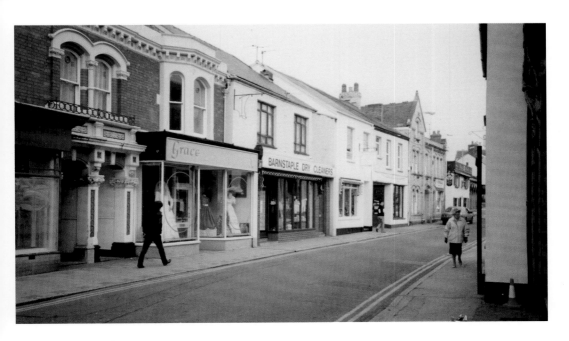

Bear Street I

There have been many changes in the 100 or more years since the previous photograph, but the appearance of the buildings has changed little in the thirty or so years between these two photographs. The chief sign of more recent times are the wheelie bins prominent to the right of the modern image.

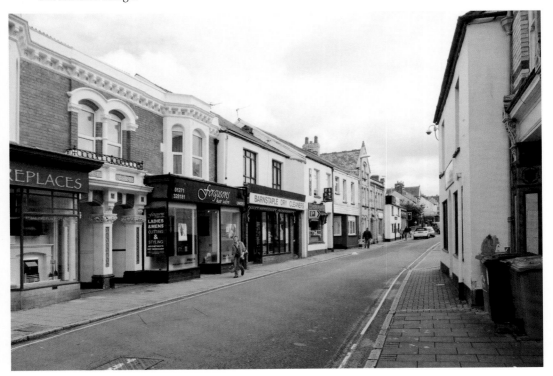

Bear Street II
This photograph shows the other side of the road. All three premises have changed occupation, and the middle property is now a private house.

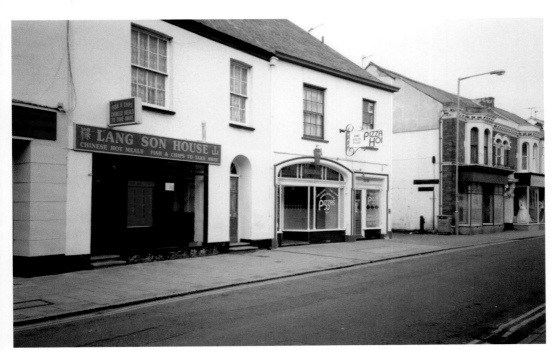

Bear Street III

Little has changed in these photographs, except for some of the business names. Even where there have been changes, the shopfronts have not been altered to the same extent as in High Street.

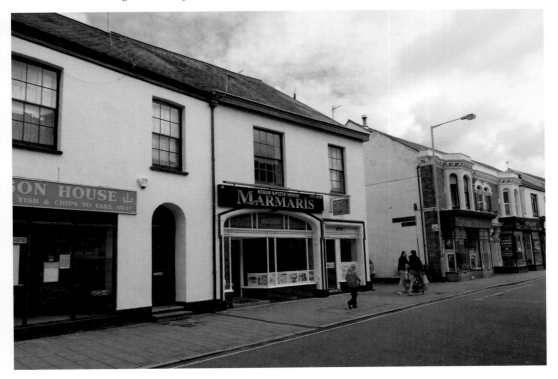

Bear Street IV

This shows the junction of Bear Street and Grosvenor Terrace with Gaydon Street and Alexandra Road. Nos 1 and 2 Grosvenor Terrace were demolished to make way for the inner relief road. Although it has now changed hands, the building of Youings & Son, masons, established in 1857, can still be seen at the left of the photograph.

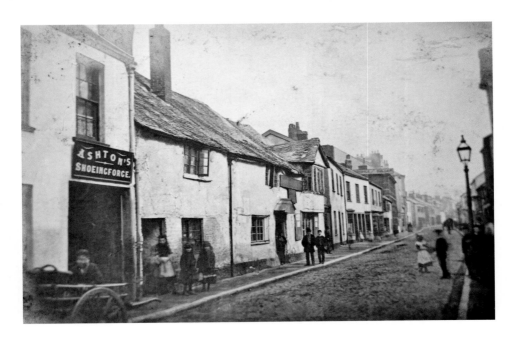

Bear Street V

Bear Street is one of the old streets leading to and from the town. The earliest recorded spelling of the name is Barrestret in 1394; it may refer to a bar or barrier at the town's entrance. This 1872 photograph shows several old buildings that have now disappeared or been hidden behind more recent frontages. Many of the buildings in the street appear to date from the late nineteenth or early twentieth century.

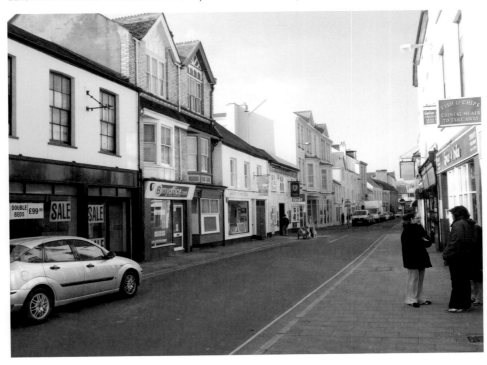

Bear Street/Alexandra Road I

This area was greatly altered by the construction of the inner relief road, and the houses in this photograph looking along Alexandra Road towards Bear Street were demolished in 1984. Excavations in 1986 uncovered the clay pipe factory of John Seldon & Son, one of the last in the country, which operated for twenty years from 1859. By 1897 the premises were part of John Huxtable's Alexandra ironworks (later Norrington-Huxtable), well-known manufacturers of agricultural implements.

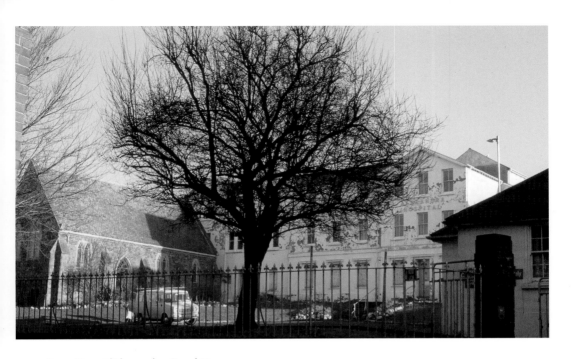

Bear Street/Alexandra Road II

Another view of the hospital. It shows the chapel, which has survived and can be seen in the modern photograph. The hospital was administered by a Board of Guardians until taken over by the new National Health Service in 1948.

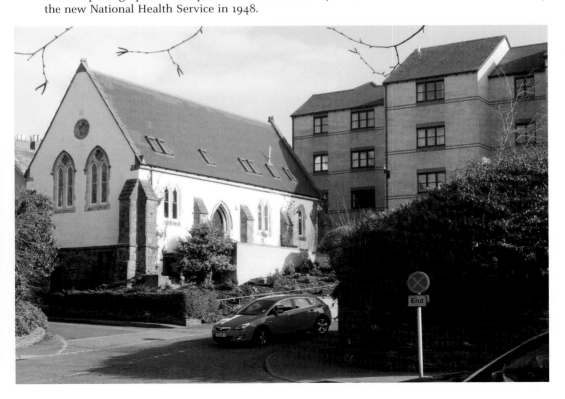

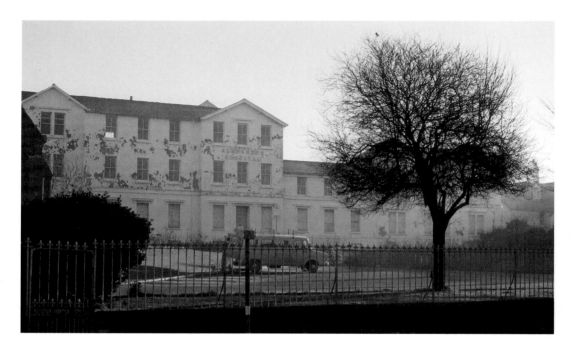

Bear Street/Alexandra Road III

This is the Alexandra Hospital, pictured before it was demolished and replaced by the present Alexandra Court Apartments. The hospital was previously the Barnstaple Union Workhouse, erected in 1837 to replace the earlier workhouse in Tuly Street, where the modern library now stands. The new workhouse cost £4,000, including £900 for the land, and in 1850 housed 220 paupers.

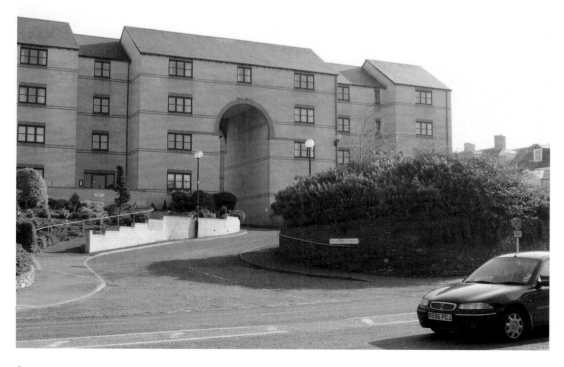

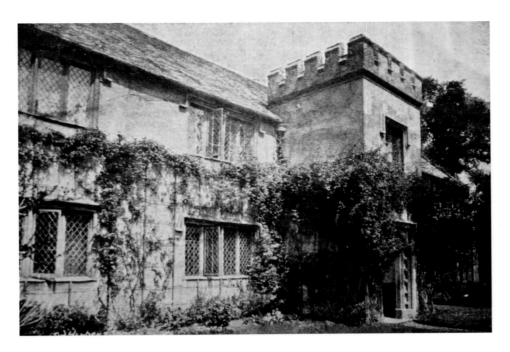

The Old Vicarage, Vicarage Street

Vicarage Street has changed considerably over the last century, but these photographs of the old vicarage show one building that has stayed the same. This vicarage was rebuilt in the first half of the seventeenth century by the vicar Martin Blake, the son-in-law of the merchant John Delbridge. It was altered in 1865 when the road was widened. The street was once known as Frogs' Lane, presumably because it led to the marshes and frogs were a common there.

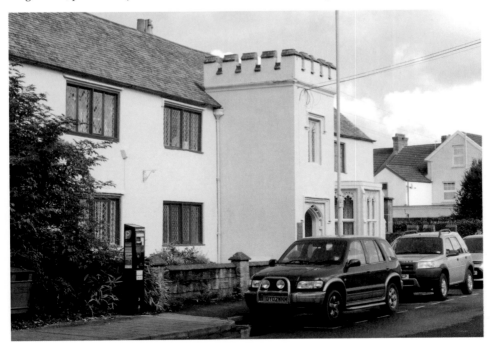

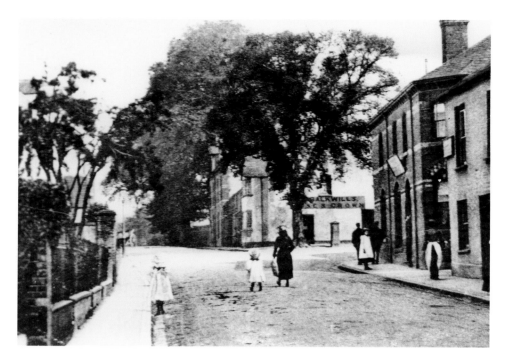

Newport I

Newport was established as a new town by the Bishop of Exeter in 1295 on his manor lands in the parish of Bishop's Tawton. Although it was never very successful, Newport remained a separate borough until it became part of the borough of Barnstaple in 1836. This early photograph was clearly taken when it was still safe to walk in the road and a very long time before the road on the left in the modern photograph was created. The Rose & Crown public house was first listed in a directory in the 1820s, and it is probably even older than that.

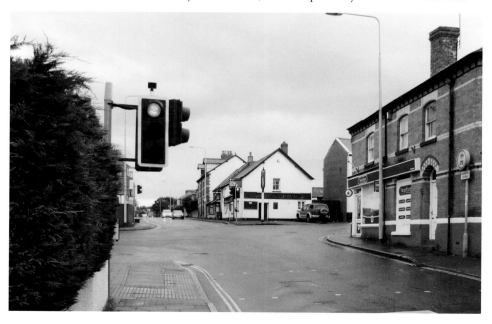

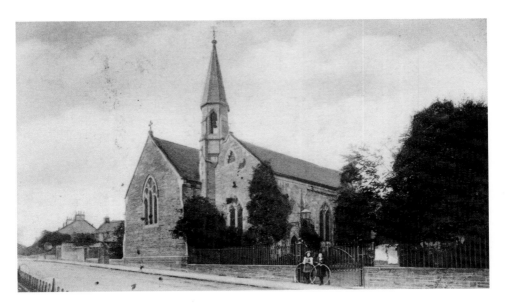

Newport II
Another view of South Street and the church. There was a medieval chapel near the site of the present church, but it was in ruins by the seventeenth century. In 1829 a new church was built, and in 1882 that church in turn was largely rebuilt. A choir vestry was added in 1928. To the left of the church can be seen the more recent addition of a church hall.

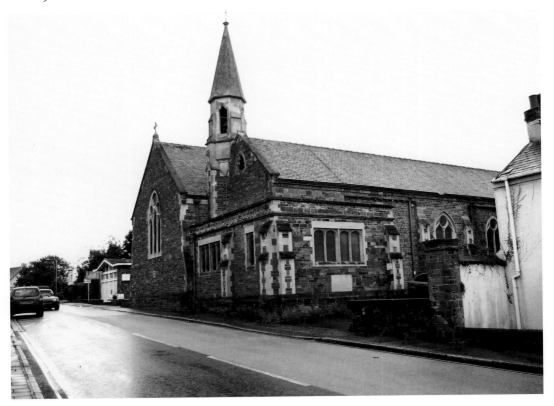

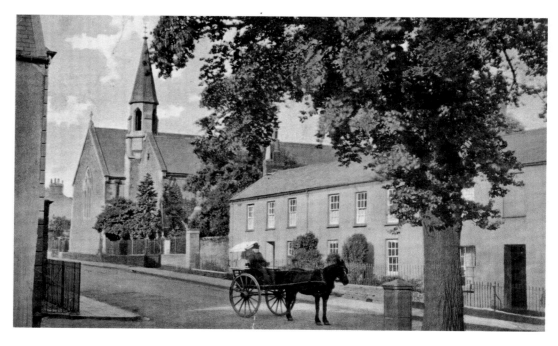

Newport III

Looking in the opposite direction to the previous photograph, this view of South Street and the church shows a scene that has changed little apart from the form of transport and the tree that is no longer there.

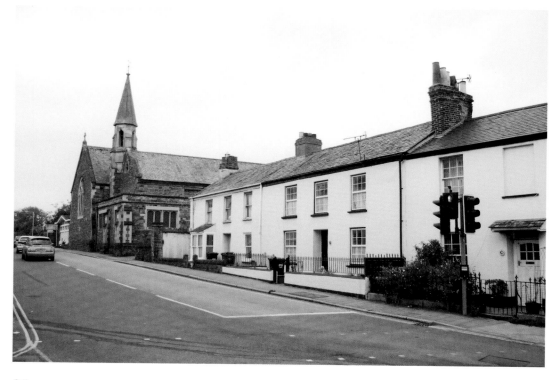

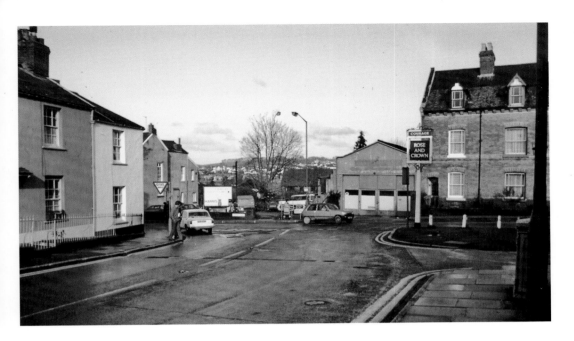

Newport IV

Although the early photograph here is much later than the previous one, it was taken before the major alteration to Newport, when Hollowtree Road was constructed in the 1980s. The name is now all that survives of the hollow tree that stood here in the early nineteenth century. Hollowtree garage was demolished, although the nineteenth-century houses to the right of the new road still stand.

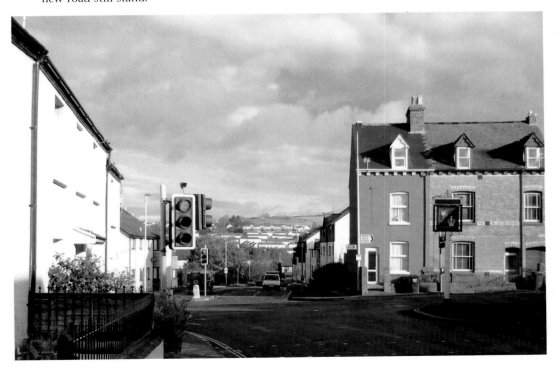

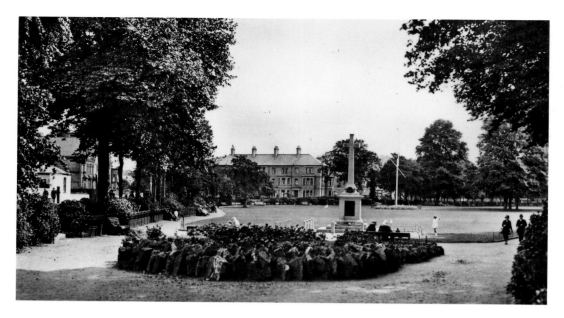

Rock Park I

There was originally a tree at the entrance to the park, but in 1912 the Town Council decided to replace it with a rockery and flowerbed, which can be seen in these photographs. The earlier photograph is undated, but must be after 1922 when the war memorial was erected. It recorded the deaths in active service of 227 Barnstaple men during the First World War. Sadly, since then there have been many more deaths in other wars, and a remembrance service is held here in November every year.

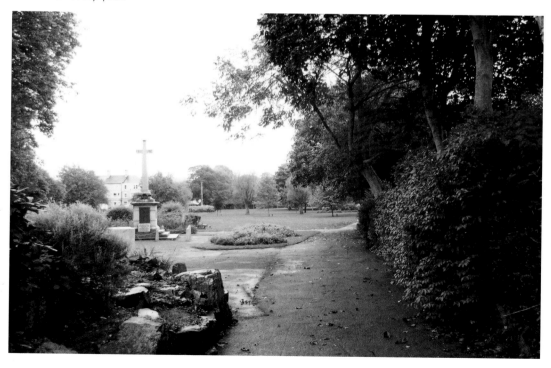

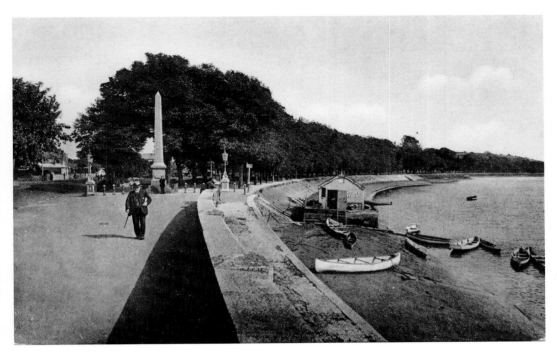

Rock Park II

These photographs are taken at the Taw Vale entrance to Rock Park, and the column recording its dedication to the public in 1879 can clearly be seen. It is named for Barnstaple's great Victorian benefactor, William Frederick Rock. Although the scene has changed little in the eighty or so years between the photographs, the boats and boathouse have disappeared. This boathouse belonged to Billy Moore, one of the town's best-known characters. At one time he had thirty boats for hire.

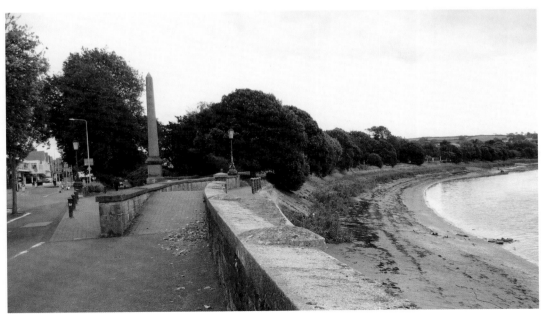

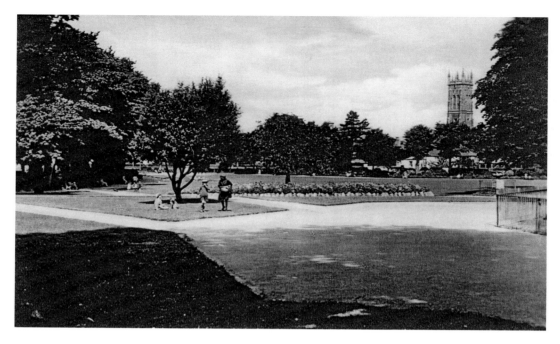

Rock Park III

There have been several changes to the park over the years. The modern photograph here shows the water pumping station, which was added in the 1980s when major flood defence works were undertaken. The tower of Holy Trinity church can be seen on the right of both photographs. The tower belongs to the church built in 1843–45, but the rest was found to be unsound and had to be rebuilt in 1867.

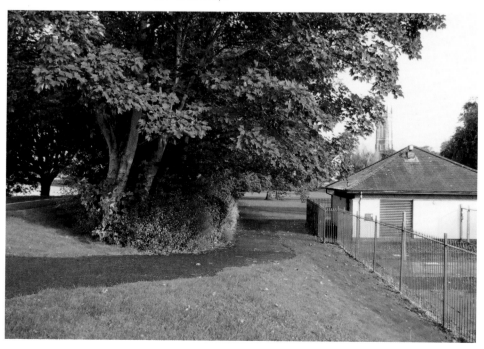

Rock Park IV

Taken in the 1970s, this photograph shows the elm trees that lined the riverside walk for many years after they were cut down due to the devastating Dutch elm disease, which destroyed thousands of elms around the country. As can be seen, the replacement trees of different varieties have now grown up and the white line down the middle of the path indicates that it is now part of a cycleway.

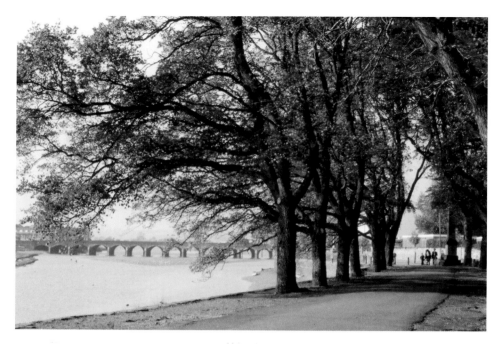

Rock Park V
A view from the riverbank near the entrance to the park towards the Long Bridge. This is a view that has changed very little, although the trees have been replaced and the riverbank is steeper now.

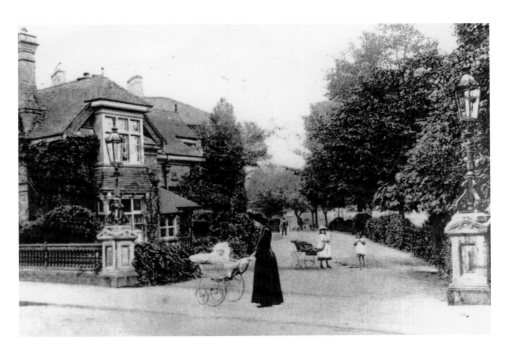

Rock Park VI

This old photograph appears to date to the late nineteenth century and shows the lodge at the Newport Road entrance to Rock Park. It was intended for living accommodation for the park-keeper and was paid for by John Payne, the business partner and brother-in-law of William Rock. The furnishings were provided by Prudence Payne, Mr Rock's sister. The lodge has recently been renovated and the scene is very similar today, although the pillars no longer support lamps, having been replaced by modern lighting.

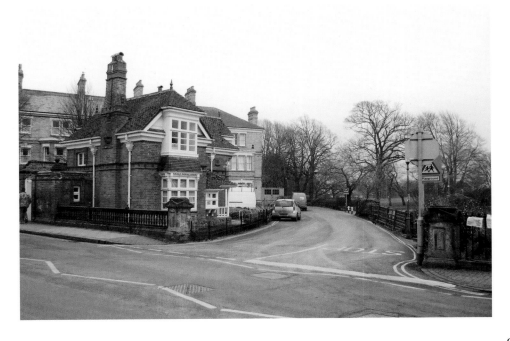

Acknowledgements

We would like to thank the following people for kindly lending us photographs from their own collections to go in this book, and for all their help in compiling it:

Col Roberts
Harry Worth
John Bradley
John Dangdown
John Norman
Justin Barrow
Martin Spencer
Michael B. Essery
Michael Coles
Mr B. Huntley
Mr K. Bates
Mr Robinson
Philip Milton
Simon Lewis
The North Devon Athenaeum
The Maureen Wood Collection

Bideford Through Time

Peter Christie & Graham Hobbs

This fascinating selection of photographs traces some of the many ways in which Bideford has changed and developed over the last century.

978 1 4456 0910 2

96 pages, full colour